# LEDBURY
## THROUGH TIME
Michael Lever

AMBERLEY PUBLISHING

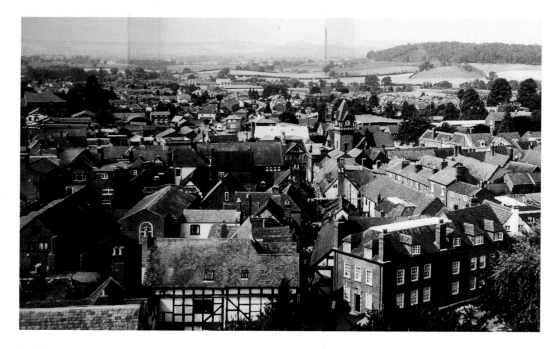

**Ledbury, 1990s**
From St Michael and All Angels church tower towards Wall Hills, this view shows the route of Church Lane. The rectangular building (foreground right) is Rutherglen, one of Ledbury's few remaining Georgian buildings. Alongside is the Heritage Centre, a late fifteenth-century Tudor building. The clock tower of the Barrett-Browning Memorial Institute shows the esteem in which Ledbury is held by residents and visitors alike, and may be summed up in Elizabeth's poem 'How do I love thee? Let me count the ways...'

## *For Clio*

First published 2013

Amberley Publishing
The Hill, Stroud
Gloucestershire, GL5 4EP

www.amberley-books.com

Copyright © Michael Lever, 2013

The right of Michael Lever to be identified as the Author of this work has been asserted in accordance with the Copyrights, Designs and Patents Act 1988.

ISBN 978 1 4456 1525 7 (PRINT)
ISBN 978 1 4456 1548 6 (EBOOK)

British Library Cataloguing in Publication Data.
A catalogue record for this book is available from the British Library.

Typeset in 9.5pt on 12pt Celeste.
Typesetting by Amberley Publishing.
Printed in the UK.

# Introduction

In east Herefordshire, close to Gloucestershire and Worcestershire, Ledbury is a small market town with a long and distinguished heritage. The land upon which Ledbury evolved was given by Edwin of Magonsaete to the bishops of Hereford. Magonsaete was a sub-kingdom of Mercia, the Anglo-Saxon kingdom of central England, whose boundaries were thought to be the same as the Diocese of Hereford, one of the oldest in England, created in 676.

Situated on a downward slope of Dog Hill Wood, with Frith Wood to the north and Coneygree Wood to the south, Ledbury faces in a westerly direction overlooking the River Leadon, a tributary of the River Severn. With hilltop camps and near the crossroads of ancient trackways for Hereford, Worcester and Gloucester, Ledbury was the ideal place for the building of a minster church.

In the Domesday Book, the place name was Liedererge. By 1135 it became Ledburia but whether Ledbury takes its name from the River Leadon or vice versa is unclear, and it may even originate from the Lydas district near Hereford. Lyde comes from an Old English stream name *Hlydee*, 'the loud one'. In those days, the River Leadon was considerably wider and wilder, and much of Ledbury is built on a floodplain. The 'bury' or 'bur' may have been a place of defence or a religious enclosure. In 1086, although by then an important market centre, Ledbury was still a village. The real founder was Richard de Capella, Bishop of Hereford. Under his guidance, Ledbury became the religious, trading and administrative centre for all activity in the area.

Ledbury is a planned town. During the Middle Ages, land for building and developing trade was made available in long narrow strips, known as 'burgage plots'. Each plot had a frontage to the main street upon which the inhabitant could build a house, the remainder of the plot being used for stores, workshops, kitchen gardens and grazing for livestock. A narrow strip of land, an alley, enabled people to get from the street to the back of the plot without having to go through the house. Ownership of a plot was not limited to use of the land. Until the Reform Acts in 1832 and 1867, burgage was the basis of the franchise in many boroughs. In boroughs the right to vote was attached to the occupation of burgage tenements. Since tenements could be freely bought and sold, and since the owner of the tenement was entitled to convey it for the election period to a reliable nominee, who could then vote, it was possible to buy the majority of the burgages and the power to nominate members of Parliament. With a fundamental difference between those that lived in the town and engaged in 'free trade' and those in the rural countryside that were servile, the legal distinction led to a division into Ledbury Urban (or Borough) and Ledbury Rural (or Foreign). In 1888, Ledbury borough became Ledbury Urban District Council and later Ledbury Town Council. Ledbury is not unique in having burgage plots, but much of its charm is in the character of the buildings and alleys.

During the Middle Ages, economic activity in Ledbury was prosperous, but after 1288, from bad harvests with famine, and the Black Death in Herefordshire in 1349, Ledbury fell on hard times, with a substantial reduction in population. It took around 200 years for Ledbury to change from being a very poor town to one of prosperity. In the sixteenth century, the reform of the church led to control of the town by a group of wealthy families. An opportunity to make their mark on the community led to rebuilding throughout much of the town and paved the way for possibly Ledbury's greatest period of prosperity, mainly through textiles and tanning. In the eighteenth century, reflecting competition in the textile industry, Ledbury's fortunes turned for the worse and it again reverted to a small, sleepy market market town.

Fast-forward to the twenty-first century and Ledbury continues to adapt and thrive. In Herefordshire, one of the more unspoilt rural counties in England, Ledbury, a hard-working and friendly community, offers much for visitors and residents. Approximately 15 miles from cities, around 8 miles from Malvern and the Malvern Hills, the population is around 10,000, 15,000 including the catchment area, and expansion is limited by the topography. Most of the town centre is a Conservation Area and Ledbury has 173 listed buildings, including three Grade I and eighteen Grade II*, but Ledbury is not a living museum. We may experience the twelfth-century layout and stroll along the compact medieval streets, flanked by timber-framed buildings, in an atmosphere steeped in history, but there have been many changes over the centuries. A visitor to Ledbury today may be forgiven for not realising how it all began.

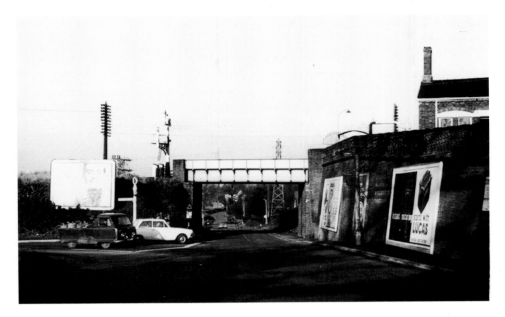

**Railway Bridge at Ledbury Junction Station, The Homend, *c.* 1964**
Approached from the north, the route into Ledbury is little changed. The right of way at the junction with Hereford Road differs. The Worcester & Hereford Railway station booking office at Ledbury station has been demolished. The nineteenth-century Station House, now a private house, was formerly occupied by the stationmaster and originally a farmhouse.

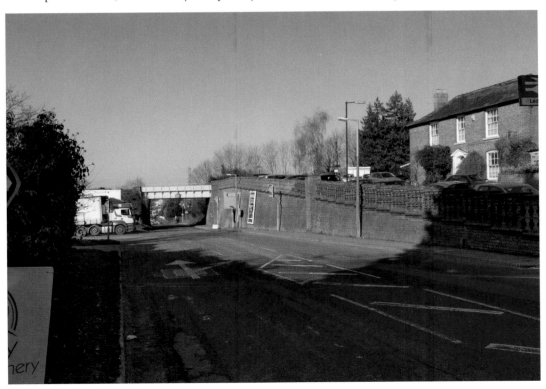

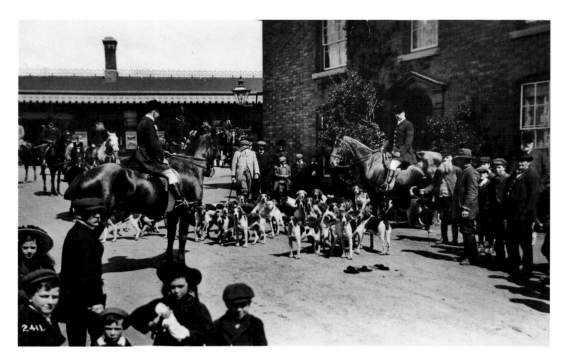

**Ledbury Junction Station, Mr Gordon Canning, c. 1909**
A master of the Ledbury Hounds in 1907 started his own pack known as 'Mr Gordon Canning's' and hunted in Newent area. What he was doing at Ledbury Junction station, which is adjacent to where the Ledbury Hunt Kennels were, the guess is that since it was the end of the hunting season he had been invited to bring his hounds for a special day in the Ledbury Hunt Country.

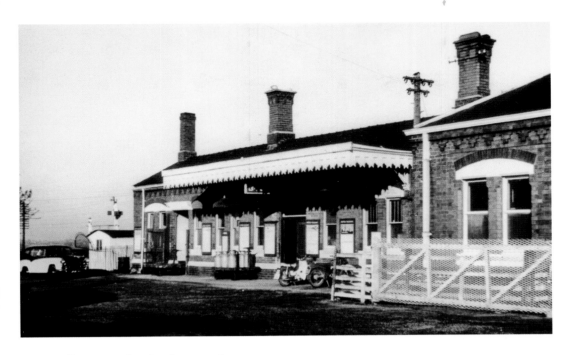

**Ledbury Junction Station, *c.* 1964**
The motorcycle at the front belonged to signalman Mr Chris Cooke. After the buildings were demolished in around 1976, and before 1993 when John Goldrick took over as the new stationmaster, the station was a dreary unmanned halt. The ticket office has been described as 'a glorified garden shed' for Britain's only self-employed rural stationmaster. At the station is the only section of double track, where trains travelling in opposite directions can pass each other, between Shelwick Junction and Colwall New Tunnel.

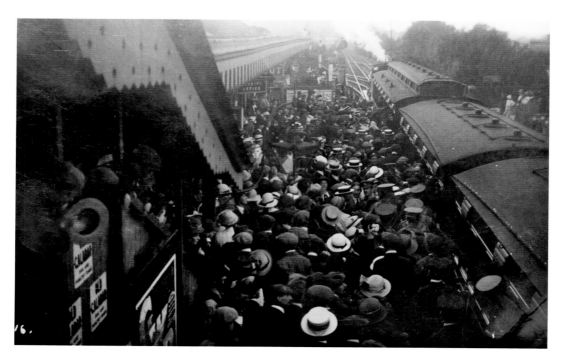

### Ledbury Junction Station Platform, c. 1914
The westbound platform was packed with well-wishers and passengers for the departure of the Territorials from the station on 5 August 1914. The old railway line to Gloucester veers off to the south. It is a far cry from an almost deserted platform on a peaceful Sunday in 2013.

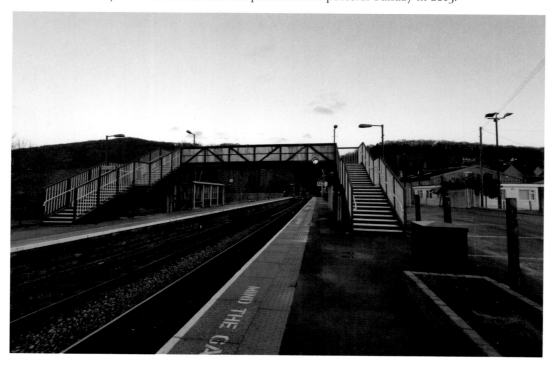

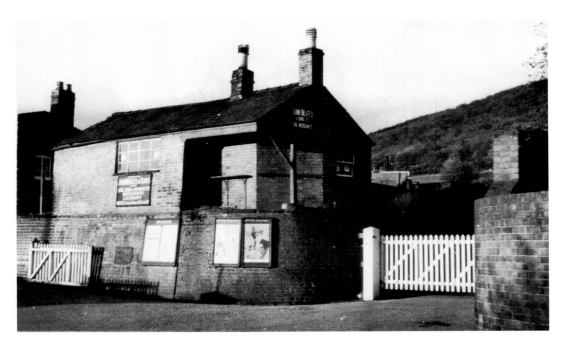

**Coal Merchant's Office, Ledbury Junction Station, c. 1964**

John Meates & Sons coal merchant's office opened in 1861, the same year that Ledbury Junction station opened on what had been a farm belonging to the Upper Hall estate. A branch line to Gloucester opened in 1885. After the Gloucester line closed, the goods yard and engine shed closed in 1965, leaving just the station. The yard was subsequently developed as the Station Industrial Estate. Forest House, on the site of the coal office, was used as offices by some local accountants and since 1991 by Playstation day nursery.

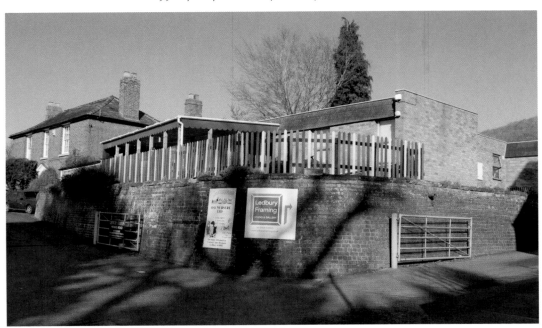

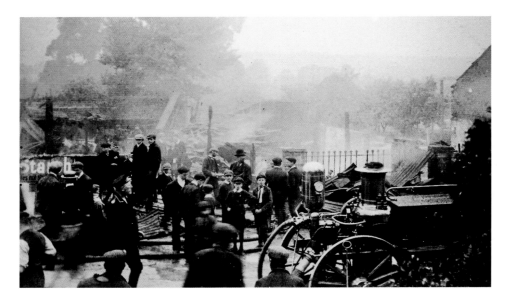

**David Smith Building Contractors Saw Mill, The Homend**
After the saw mill was destroyed by fire on 31 August 1908, the revamped site on the corner of Orchard Lane was occupied by F. C. Swift & Co. agricultural and motor engineers. Next came Alex Cowan & Sons Ltd, an envelope-maker. In 1967, Cowan was acquired by Reed International and became part of Spicers. After Spicers relocated to a building on the bypass, where Galebreaker is now, a Tesco supermarket opened on 18 August 1997, almost two weeks short of eighty-nine years since the fire.

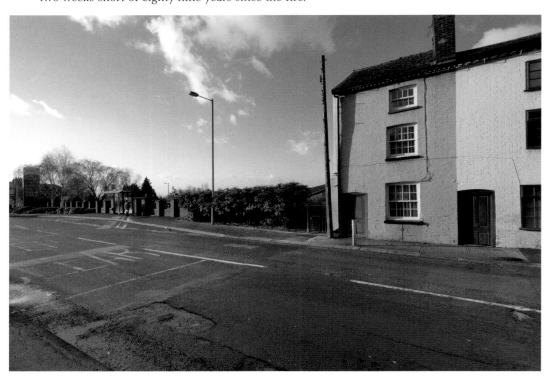

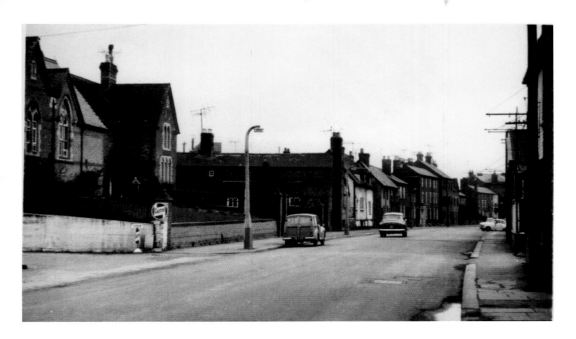

**Boys School, The Homend, _c._ 1964**

Before 1987, when Dawes Court, a block of flats, was built, fronting The Homend and Homend Crescent was the Boys' School, opened in 1868 and enlarged in 1894 to accommodate 230 boys. Dawes Court is named after the Very Reverend Richard Dawes, Dean of Hereford Cathedral and Master of St Katherine's Hospital, as this school was founded largely through his efforts. All that remains of the school is a wall in The Homend and remnants in Homend Crescent. The school bell tower was lifted off by crane and removed to Longacres where it now rests in the grounds of Ledbury Primary School.

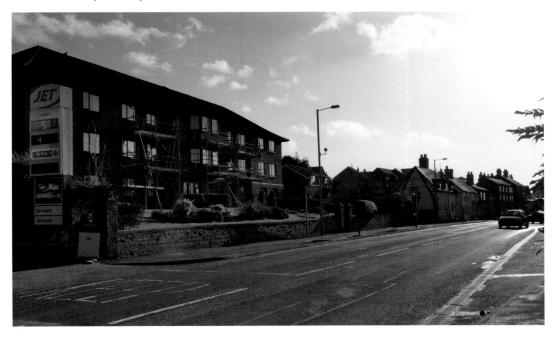

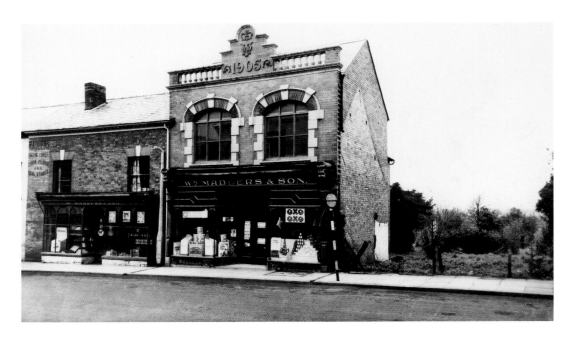

**Nos 86–88 The Homend, 1930s**

The shop at No. 86 is a seventeenth-century timber-framed building with nineteenth-century alterations. No. 88 appears to have been built in 1905; a replacement in the 1970s was required after a lorry crashed into the building. Ike Madders, of Wm Madders & Son, had been a distinguished figure in the town, invariably wearing a grey homburg hat, carrying a cane and able to quote lines of poetry on most subjects. Ike Madders was father of the late Sue Harling, whose late husband, Peter Harling, was thrice mayor of Ledbury.

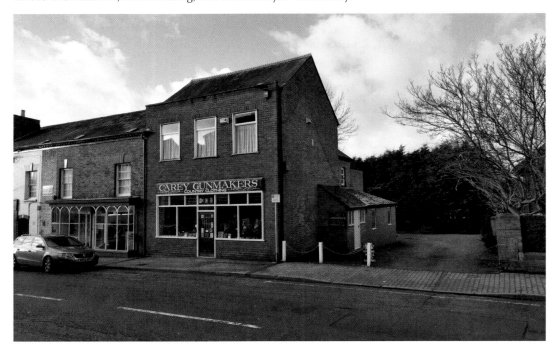

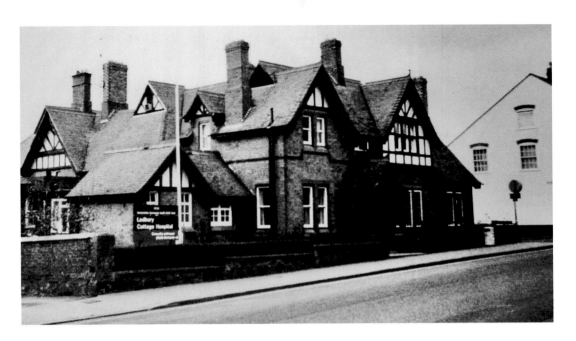

**Cottage Hospital, The Homend, c. 2003**
Founded in 1872, the present building dates from 1891 to 1899, when it was funded by Michael Biddulph MP to mark the coming of age of his eldest son, John. The hospital was built on the site of a cider and perry factory, whose orchard was developed for housing by Ledbury Benefit Building Society – now Belle Orchard. After 1948, the NHS hospital took over the running until it closed in 2002. In 2009 the building was converted into apartments and workspace and renamed the Old Cottage Hospital.

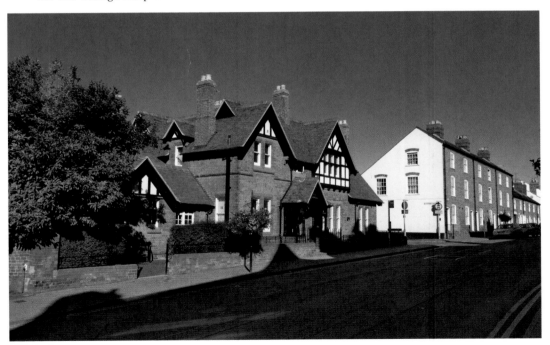

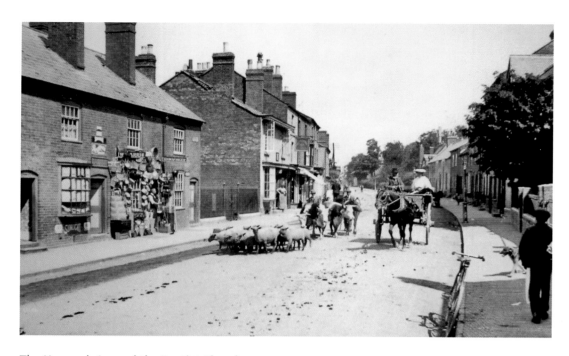

## The Homend, Around the Baptist Church, c. 1905

Viewed from the south, this scene has, apart from the cars instead of horse and cart and an absence of livestock, hardly changed since the early twentieth century. The shops next to the railings in front of the Baptist church, itself built in the 1830s, have reverted to residential use and form part of a Grade II listed terrace of houses.

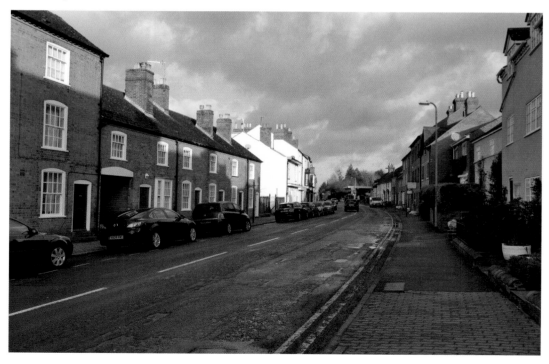

**The Plough Inn, No. 74 The Homend, c. 2003**
In this eighteenth-century building, a landlord's wife's daughter was born just before the 1881 census and had not been named even though she was then two weeks old. The Plough Inn closed in the 1990s, the ground floor becoming a florist. Plough Yard was developed as seven houses. To encourage owners not to use their cars, a selection of bicycles was provided by the developer together with a contribution towards public transport costs. The end-terrace house has been converted into a shop and flats.

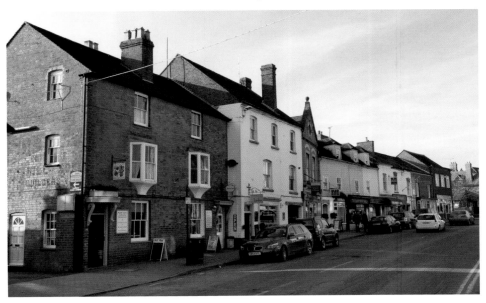

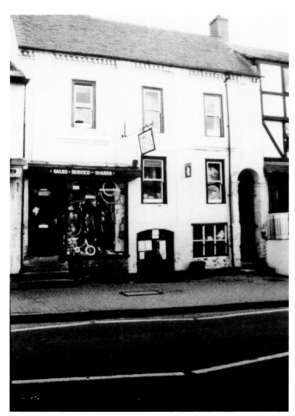

**Powell Cycles Shop, No. 67 The Homend, c. 2003**

Pip Powell, of Powell Cycles, was seventy when he died in 2010. A local character born above the shop, he was a shopkeeper all his life and a fount of knowledge about the history of shopping in Ledbury. The cycle shop had been started by his father, James, in 1923. After his father's death in 1960, Pip continued the business until he too passed away. In the 1940s there were five cycle shops serving a population of about 3,500.

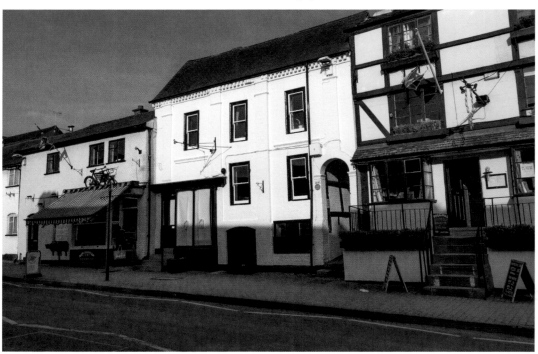

**Building in the Fox Lane, The Homend,** *c.* 2011
During recent years, much speculative residential property development has been carried out in Ledbury on pockets of infill land. These two new houses, named Jetty Cottage and Leadon Cottage, show what can be done with imagination.

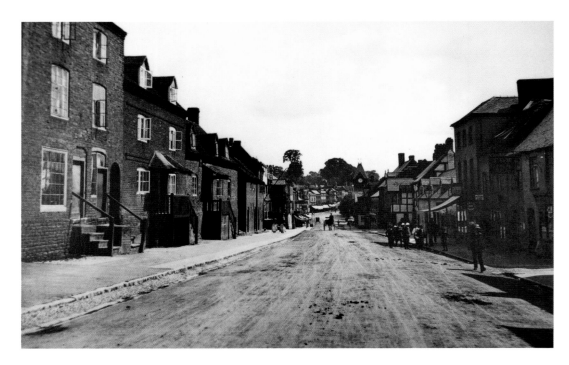

**The Homend, 1900s**

From a northerly direction, the east side of The Homend has changed considerably. Bank Crescent was not built. The pavement is raised with steps onto the street. The old houses have been replaced by modern flats – what used to be Turner Court.

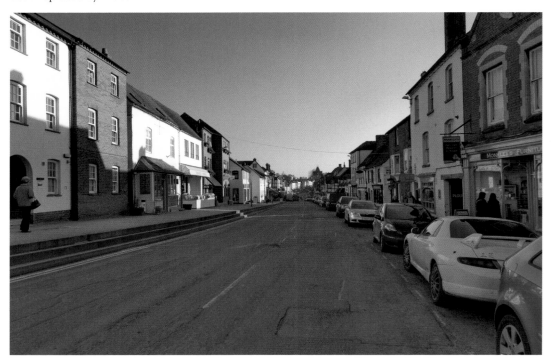

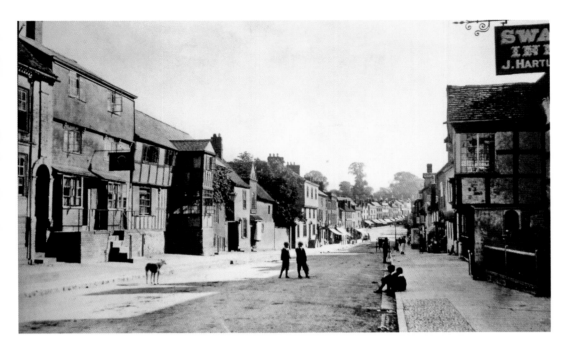

### The Homend, 1900s

By the 1920s, with modern transport making an appearance, the Swan Inn had become Swan Cycle Works. It is now The Olive Tree restaurant. On the east side, the Horseshoe public house is still there. Next door was the Abbey School for young ladies. The era is long past for idyllically relaxing in the middle of the street!

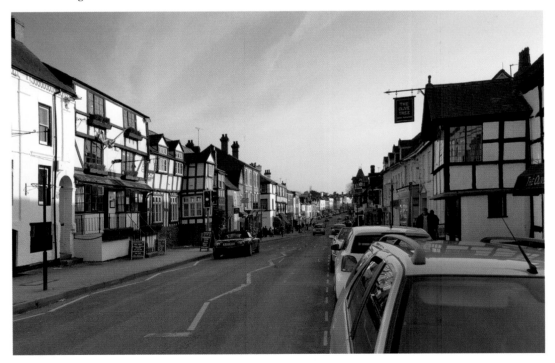

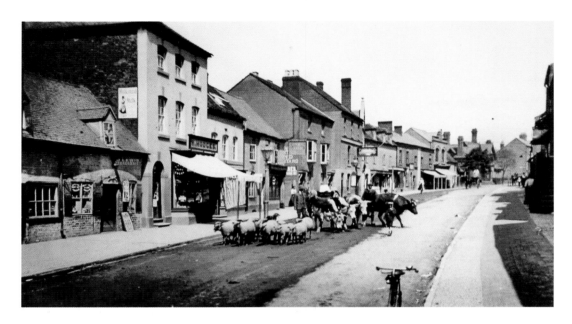

**W. Hodges, No. 50 The Homend, 1900s**

Around the time of the Second World War, No. 50 The Homend was occupied by Mr Gabb, the baker. During the 1930s and 1940s, Ledbury shops closed on Christmas Eve. If you'd forgotten it or under-bought, Mr Gabb was your saviour. He would bake early on Christmas mornings and take out the batch of bread to supply latecomers. Waiting in the nearby alley would be housewives with the beef (turkey was expensive). As Mr Gabb removed the bread from the hot oven, he would put in the roasting pans of meat, to be delightfully and thoroughly cooked in time for dinner.

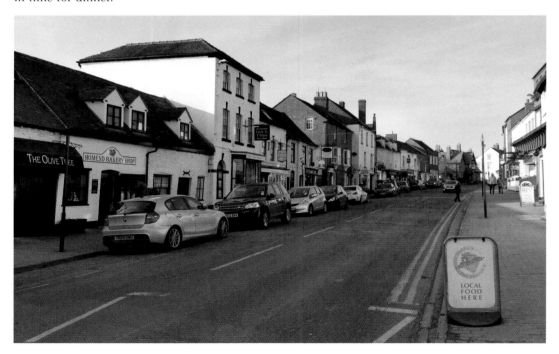

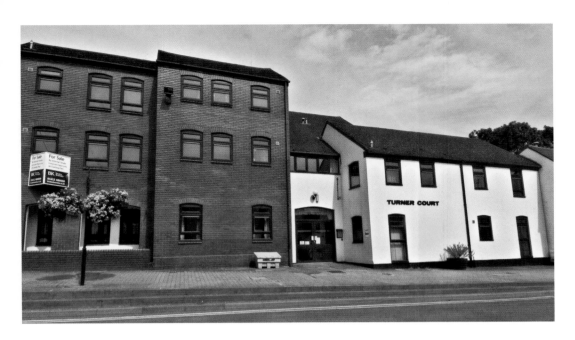

**Turner Court, The Homend, *c.* 2010**

On the east side of The Homend, Turner Court, named after a former chairman of Ledbury Town Council and owned by Elgar Housing Association, was sheltered housing flats and home to more than twenty elderly residents until vacated and sold to a developer in 2010. The ground floor of the building has now been converted into offices and a tapas bar.

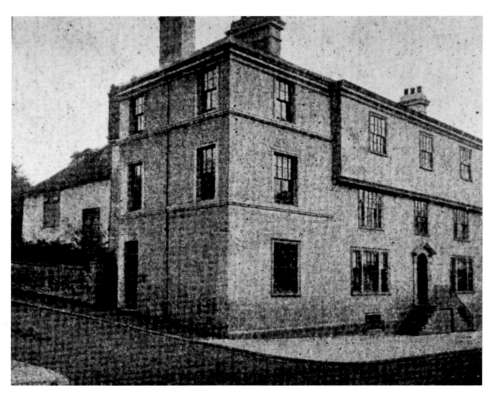

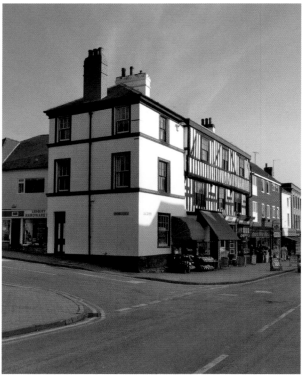

**The Bank House, Nos 27–29a The Homend, c. 1905**
On the east corner with Bank Crescent, The Bank House, a seventeenth-century mansion with eighteenth-century additions, predates a change of use in the 1920s to a cinema. Part of Bank Crescent was laid out for housing by the early twentieth century, the remainder in the 1920s and 1930s. Bank Chambers, now No. 1 Bank Crescent and a private house, was also the registry office and is probably where the poet W. H. Auden and Erika Mann married in 1935.

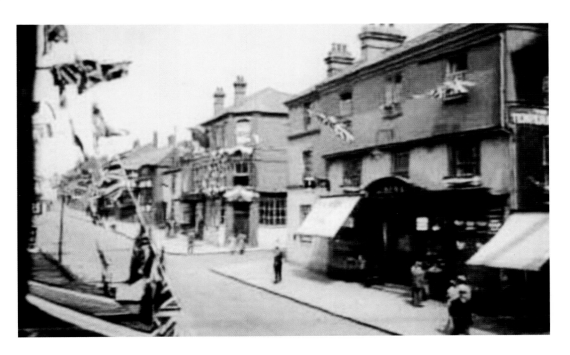

**Cinema House, The Homend, *c.* 1953**

Originally The Bank House, the building became known as Cinema House during the 1920s. As Sue Harling recalled, 'We used to queue up Bank Crescent because we always sat in the 1/9*d*. When we went with my mother and father. Upstairs the price was 2/3*d*; better seats altogether. Children used to queue in the Homend to get in for 10*d*, where they sat on benches.' The Cinema was popular until 1961, when it closed following the decline of cinema nationally. It reopened after about six months and then closed for good.

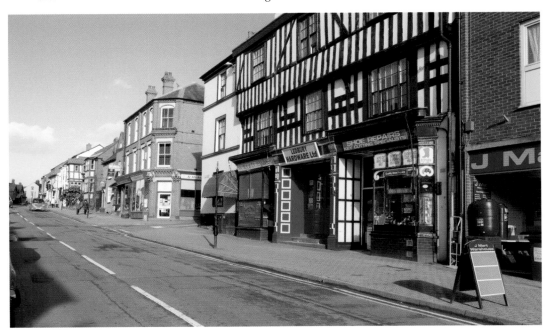

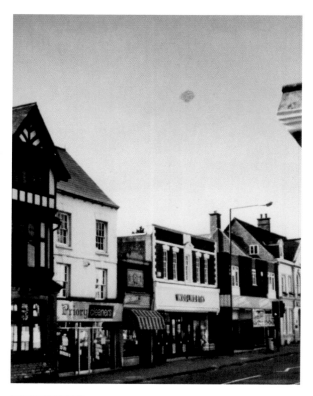

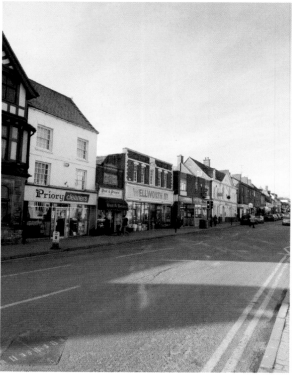

**Shopping in The Homend, *c.* 2003**
F. W. Woolworth opened in the early
1930s in a new building – what had
been a corn and feed merchant.
Supermarket Lo-Cost, owned by
Argyll Foods, later Safeway UK
until acquired by Morrisons in
2004, predated the sub-post office.
Originally, the sub-post office was on
the corner of Bank Crescent. Belisha
beacons, named after Transport
Minister Leslie Hore-Belisha, aided
pedestrian crossing. For a time, the
sub-post office relocated to No. 38
The Homend (now Ice Bytes) until its
place at the back of a One Stop store.

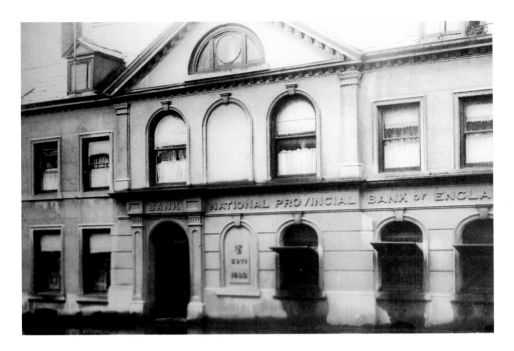

**National Westminster Bank, The Homend, c. 1900**

National Provincial Bank Ltd, incorporated 1 July 1880, was established as a provincial bank but with a London head office. It was structured to be a branch banking enterprise concentrating on a large number of smaller accounts rather than a small number of larger accounts. In 1835, a branch opened in Ledbury and, quickly becoming successful, relocated to Homend House where it has remained since. In 1970, National Provincial Bank merged into National Westminster Bank, part of RBS Group since 2000.

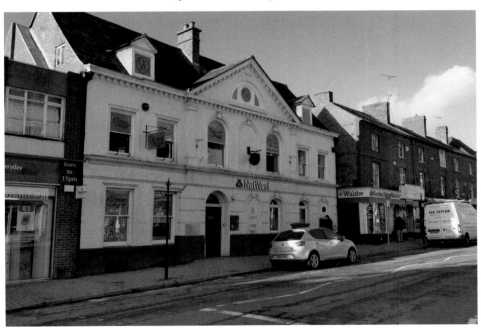

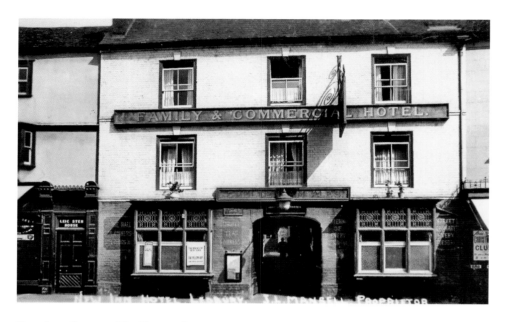

**New Inn, Nos 5–7 The Homend, *c.* 1900**

A late seventeenth-century public house, previously called the Crown or Old Crown, by the mid-nineteenth century New Inn had become a centre for carriers, with transport to Cheltenham, Gloucester, Tewkesbury and Worcester. At the rear of the inn, the overhanging extension was an Assembly Room, a vogue by the end of eighteenth century. In the 1970s, the inn closed and was converted into shops and flats. Homend Mews, the renamed outbuildings and courtyard, is described as an 'oasis of peace'.

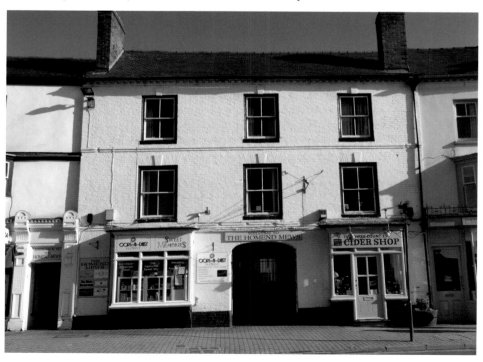

**Seven Stars, No. 11 The Homend, *c.* 2001**
Built in the late sixteenth century, possibly a private house before then, the Seven Stars, one of the oldest pubs in Ledbury, was almost destroyed by fire in 2001, only the façade remaining. There were no injuries, and occupants and nearby residents were evacuated. After nineteen hours, firefighters left the scene. Rumours abounded but, in 2002, the landlady was cleared by a jury at Hereford Crown Court of starting the fire and recklessly endangering life. During the restoration work, a priest's hole was found at the top of the building, and a bake oven in the big chimney.

**No. 1 The Homend,** *c.* 2006

One of the earliest seventeenth-century timber-framed buildings, the appearance is late eighteenth-century re-fronted. The building, also fronting Market Place, occupies a commanding position. An example of market encroachment can be seen where the original building line has been extended. The name 'Warwick House' used to be on a parapet, possibly associated with the former Warwick House department store in Malvern. In the latter part of the twentieth century, the shop fronting The Homend was occupied by the Tourist Information Centre. Despite a petition attracting hundreds of signatures in just a week, the TIC was relocated.

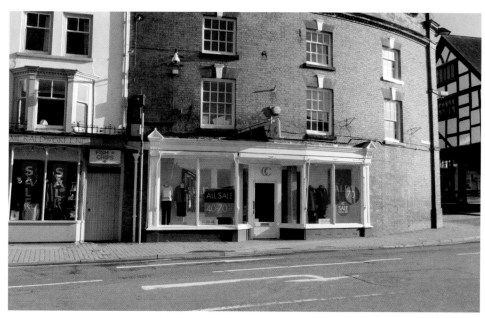

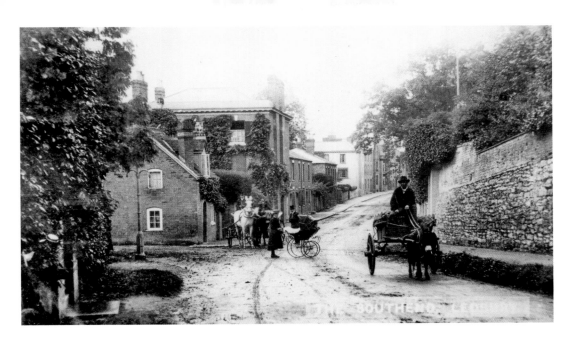

**The Southend,** *c.* **1908**

Approaching from the south, the distinctive Gloucester House, a large eighteenth-century Georgian house at right angles to the road, nestles behind the little Road Toll House, thought to have been built for the Turnpike Trust in 1840; the path alongside leads to Mabel's Furlong. The brick wall opposite, much of which is now Grade II listed, belongs to Ledbury Park.

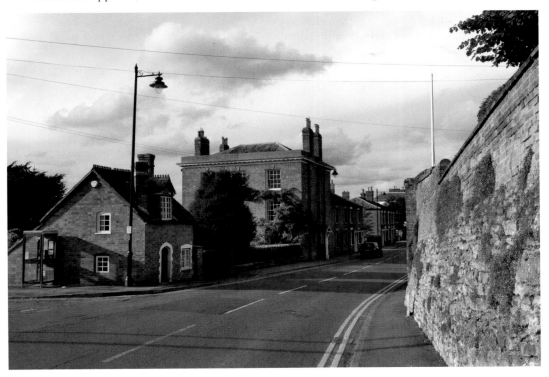

Mabel's Furlong, *c.* 1900

Lady Katherine Audley lived at the Manor of Much Marcle Audley (now Hellens) until pressure there became too much for her. On 25 February 1308, the Coronation of Edward II, she went missing and ended up as a recluse in Ledbury. Immortalised in a William Wordsworth sonnet and an essay by John Masefield, it is said she would wander until she heard church bells rung without ringers – having heard that sign, she stayed with her maidservant Mabel. In the seventeenth century, the fields were known as Mabley Furlonge. During the Second World War, it became a prisoner of war camp. After 1945 until around 1959 the Nissen huts were used as temporary accommodation. Mabel's Furlong was developed for housing. The camp was developed for John Masefield High School which opened officially on 6 October 1978.

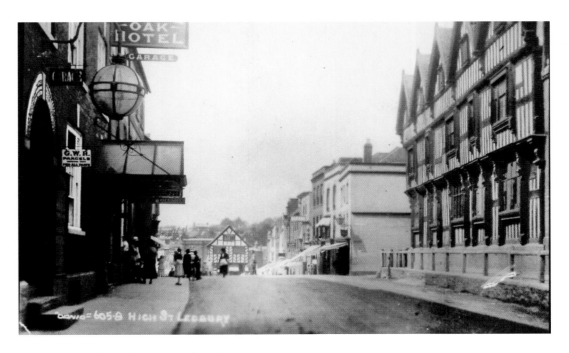

**Royal Oak Hotel, The Southend, c. 1923**

The Southend is one of the original medieval streets of Ledbury, recorded from at least 1288. Of the six public houses and inns on this street, only the Royal Oak Hotel, a coaching inn since 1645, remains. It is dated about 1520; the rear part was possibly a cider house in 1420. In 1902, the adjacent Royal Hall, a popular venue with seating for 500 people, was licensed for meetings, theatre and concerts.

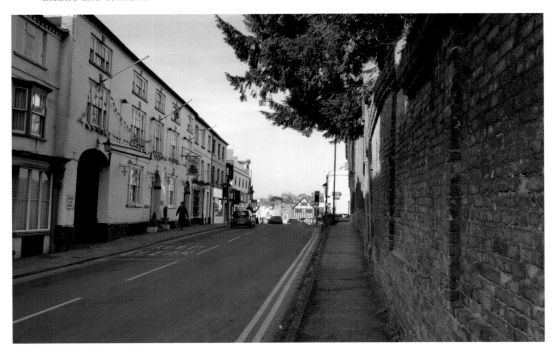

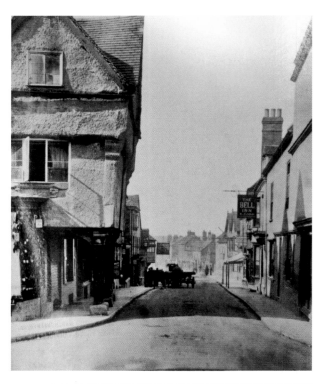

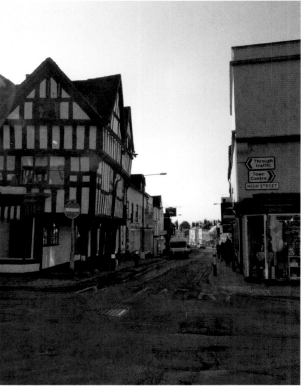

**House on Stilts, Upper Cross,**
*c.* 1890
Upper Cross (also known as
Top Cross) is the junction of
High Street, New Street, The
Southend, and Worcester Road.
In ecclesiastical towns, a cross
marked the spot where a member
of the clergy would say prayers to
help keep the peace while market
traders went about their business,
also to collect dues; a cross was the
forerunner of the market hall. Of
the 'House on Stilts', *c.* 1600, one of
the oldest timber-framed buildings
in Ledbury, it is thought that
the ground floor was originally
exposed and used as a market hall.

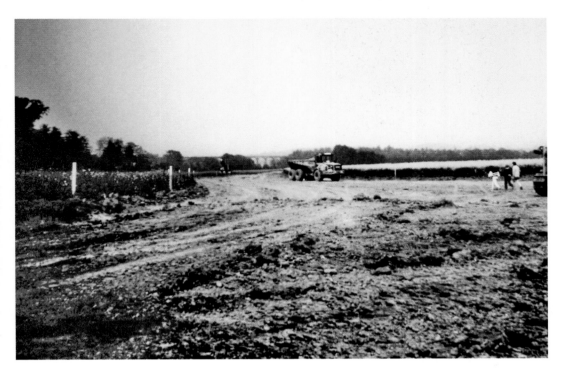

**The Bypass, Leadon Way, *c.* 1989**

Before the bypass, the only way for vehicles to travel from north to south was through town, with much congestion at Upper Cross. In 1972, plans for an inner relief road, known as the Upper Cross bypass, proved controversial. In 1989, the outer relief Leadon Way was constructed. Before work could be completed, the meandering River Leadon had to be diverted.

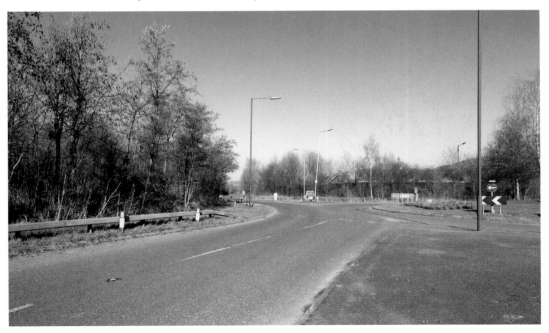

**The Lodge, Worcester Road, *c.* 1904**

In the east, Worcester Road (A449) winds past The Lodge and the entrance to Upper Hall estate. Before Worcester Road was realigned and The Avenue widened, the old route east was along Back Lane (now Church Street), Green Lane (a track along Dog Hill Wood) and Cut Throat Lane. ('Throat' derives from a pre-seventh-century word '*hraca*', meaning a narrow pass or cleft in a hillside.) A pedestrian shortcut in front of Upper Hall was curtailed when the footpath was stopped up and the estate road made private.

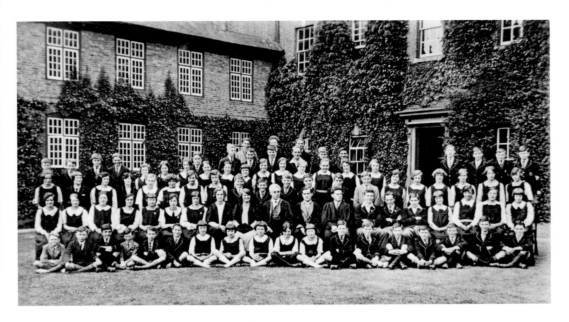

**Ledbury Grammar School, Upper Hall, 1924–25**

Traceable back to 1201, of Jacobean, Georgian and Victorian construction, Upper Hall belonged to the Skyppe family until 1812, but their successors the Martins, a banking family, transformed the external setting surrounding it with parkland. By 1920, 'Upper Hall comprised a commodious family mansion, picturesquely situated and containing a suite of well proportioned reception rooms and twenty-seven bedrooms'. That year Upper Hall was sold to Herefordshire Council for Ledbury Grammar School. During the Second World War, the school was used as a hospital. In 1978 the buildings were used by John Masefield High School. In around 1997, after a period of disuse, the property was sold to a developer and converted into apartments.

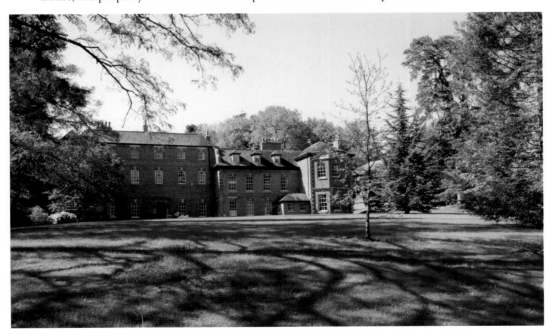

**Solicitors' Offices, Worcester Road, *c.* 1912**

John Masefield, poet, was one of six children born to George Edward Masefield, a solicitor in the family firm, established *c.* 1836. His grandfather, also George, had moved from Shropshire and married Frances Mary Holbrook, the daughter of the local solicitor, whose practice George subsequently took over around 1930. The neighbouring cottages, including a toll-house, were demolished in 1953 for the opening of the police station the following year. Opposite, the former orchard belonging to Ledbury Park was developed for housing and renamed Horse Lane Orchard. Horse Lane was widened and renamed Worcester Road.

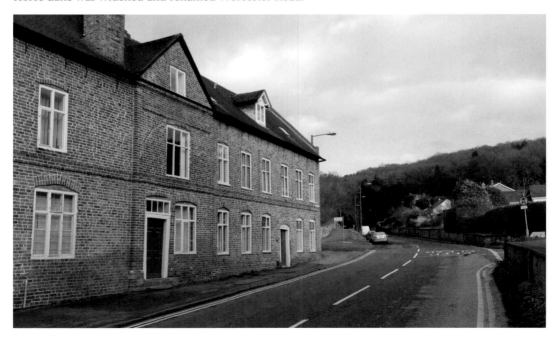

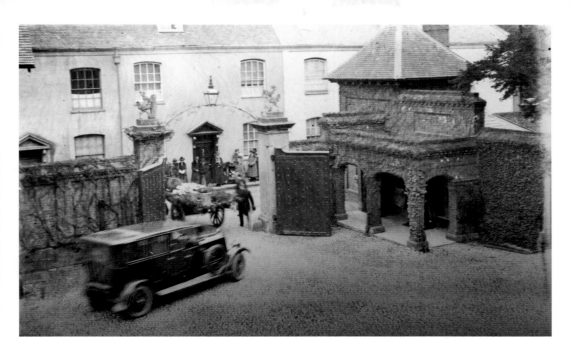

**Entrance Gate to Ledbury Park, *c*. 1908**
By reason of highway safety in Worcester Road, these Grade II listed entrance gates to Ledbury Park are unlikely to be used open again for vehicles. The lodge, early nineteenth century, was originally built as a dovecote. H. J. Chapman, a stationery business, acquired in 1989 by the WHSmith group, occupied Ledbury Park in 1951 until the business was closed in 1996.

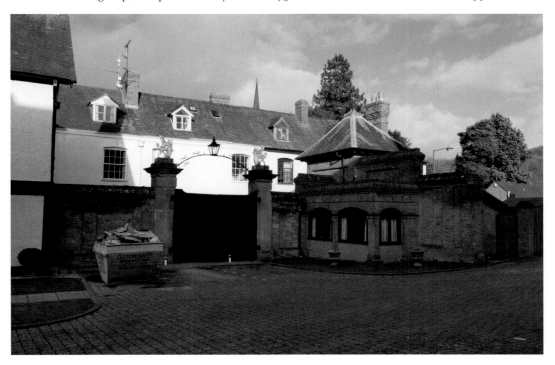

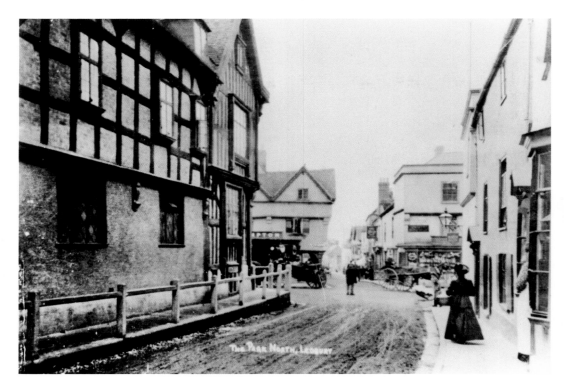

**Worcester Road and Upper Cross, 1890s**
Into the town centre an easterly view of Upper Cross, with New Street in the background and the House on Stilts on the corner. On the south side, the extensive, largely blank wall of New House, Ledbury Park, can be seen; the railings alongside in Worcester Road have been removed.

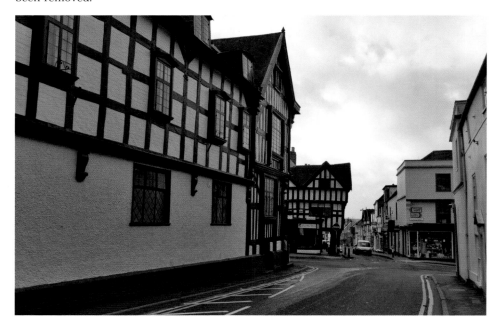

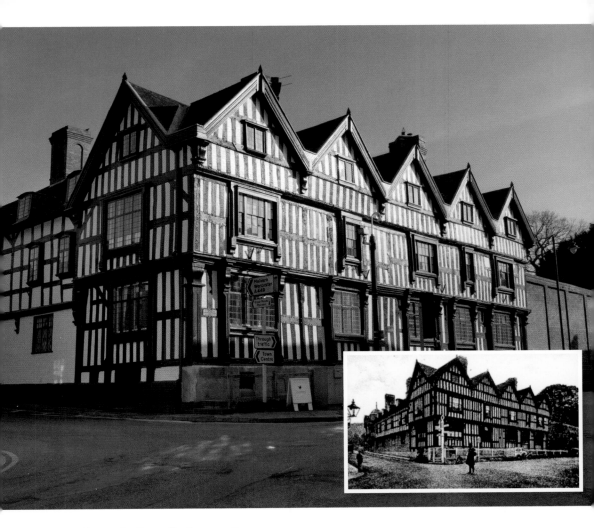

**New House, Ledbury Park, c. 1908**

New House, a Grade I listed sixteenth-century mansion, whose name changed to Ledbury Park in 1820, is considered the most important domestic building in Ledbury, belonging to Edward Skynner, a clothier, in around 1595. Edward and his wife Elizabeth are buried in the church, with their baby daughter, who was reputedly killed by the last wolf in the district. In 1680 the estate passed to the Biddulph family, an influence in Ledbury into the twentieth century. Unusually, for a grand mansion, the building is on the corner of busy streets. During the Civil War, Prince Rupert made New House his headquarters. In 1830, Princess Victoria (later Queen Victoria) named an elm tree on the estate. The parkland is an Area of Outstanding Natural Beauty. In 1996, the buildings were converted into houses and apartments.

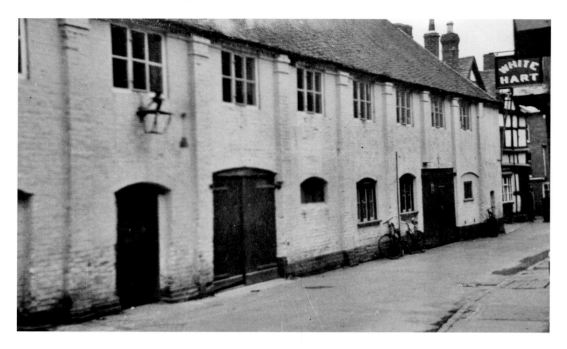

### The Old Fire Station, Church Street, 1920s

Church Street, previously Hallend, named after the Lower Hall estate nearby, was the old route for the east, a narrow, winding street to Dog Hill Wood. After Worcester Road was opened, Church Street was known as Back Lane. Since 1926, when the fire station relocated to Bye Street, the building has been occupied by Ledbury Royal British Legion Club, formed in 1925. In 2001, the White Hart, now a private house, ceased trading after the licensee thought his wife was having an affair with a customer and struck him with an axe; fortunately his injuries were minor.

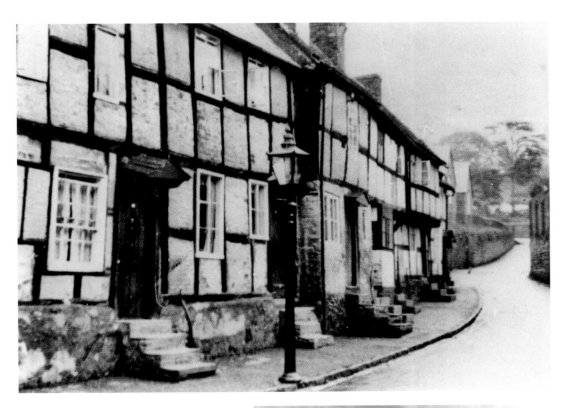

**Old Cottages and Schools, Church Street, c. 1910**
The gable or saddle roofs, towards the top of Back Lane, Church Street, are of the former Girls' School and Infants' School, built around 1850. The schools were demolished in 1983 for a housing development. The old cottages, built in the seventeenth century, were replaced in 1974 by St Michael's flats.

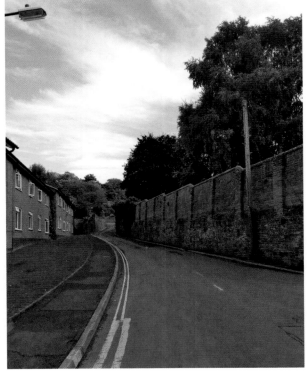

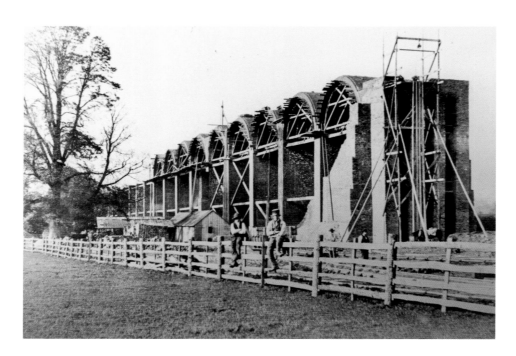

## The Viaduct, *c.* 1858

For the Worcester & Hereford Railway Company in tunnelling through the Malvern Hills and the building of the viaduct, the contractors were Thomas Brassey and Stephen Ballard. Tunnelling began in 1856 and was fairly easy until the depths of the Malvern range of syenite, a hard, tough granite, blunted the tools, whereupon almost half the tunnel had to be cut manually, taking four years to complete, in 1860. For the viaduct, now Grade II listed, work commenced in 1854 and the viaduct opened in 1861. Thirty-one arches span the Leadon valley; the five million bricks were baked on site from local clay.

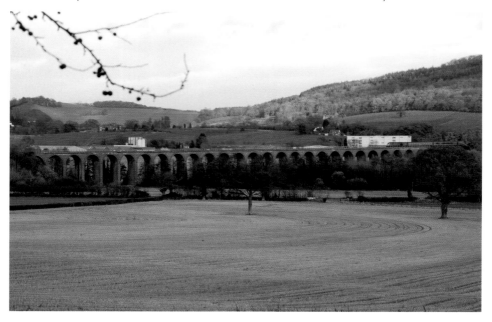

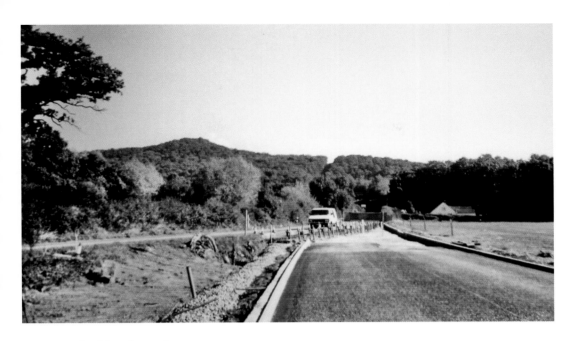

**Hereford Road, *c.* 1989**

From the west, the old route of Hereford Road was changed when the last phase of Leadon Way bypass was constructed in 1989. The line of the old road remains as a strip of undeveloped land off Saxon Way. New Mills housing estate, named after a seventeenth-century mill, was developed on the south side of Hereford Road, bounded by the bypass. On the north side of Hereford Road, in the mid-twentieth century, were open-air swimming baths. At the foot of the former railway embankment, now the Town Trail, and west of the skew bridge over Hereford Road, the bungalow is there still.

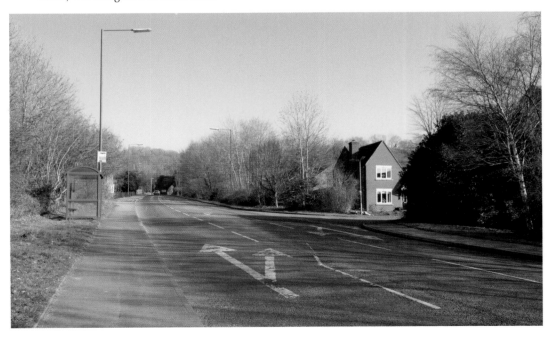

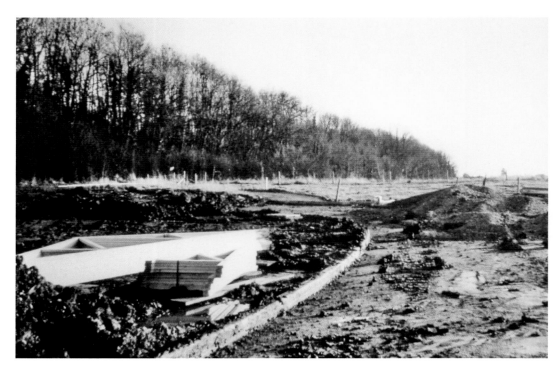

Golding Way, New Mills Estate, *c.* 1993

New Mills housing estate is laid out in cul-de-sacs. The first phase was Golding Way and Challenger Close, each street in the early phases named after a type of hop, such as Viking and Saxon. The street names in later phases are named after poets, including Auden, Frost, Brontë, Browning, and Farjeon, and Civil War military figures such as Prince Rupert.

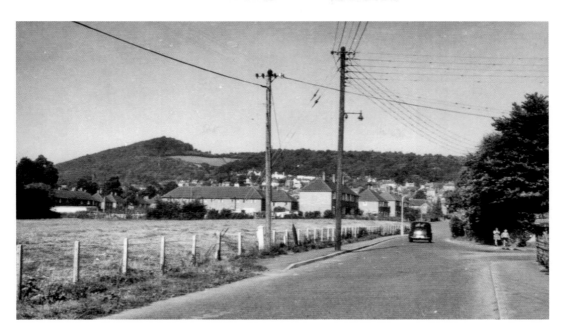

**Lower Road, South of Victoria Road, *c.* 1964**
Until the latter twentieth century and before Lower Road Trading Estate was developed, much of Lower Road was surrounded by open fields. This area of Lower Road was known as Newtown. The brick for the properties may have come from one of the two brickworks nearby. Victoria Road and Albert Road had developed gradually since the mid-nineteenth century. In 1947 floodwaters from the River Leadon reached Victoria Road.

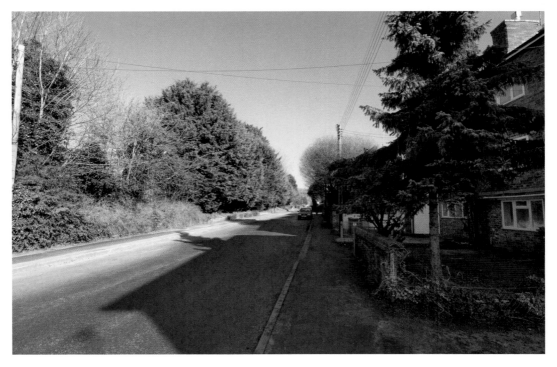

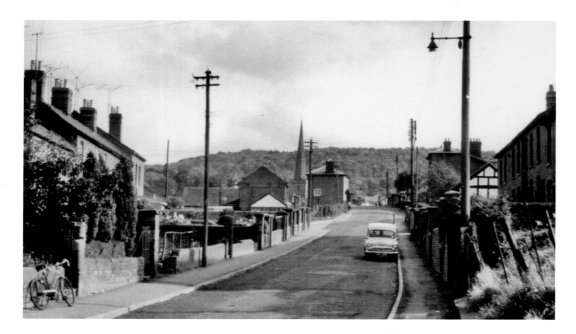

**Bridge Street, c. 1963**

A continuation of Lower Road, much of Bridge Street was developed in the latter half of the nineteenth century by Ledbury Benefit Building Society, and the area known as Happy Land. Originally, the bridge was constructed for the Herefordshire & Gloucestershire Canal. In 1881, the Gloucester to Ledbury section was closed and the whole canal became disused a year later. A stretch of canal bed was reused by Gloucester & Ledbury Railway, which opened in 1885, by which time the old canal bridge had been reduced in height.

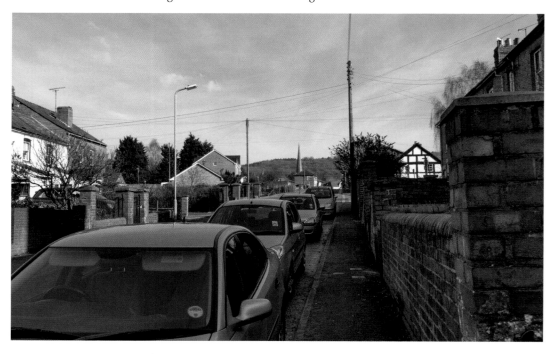

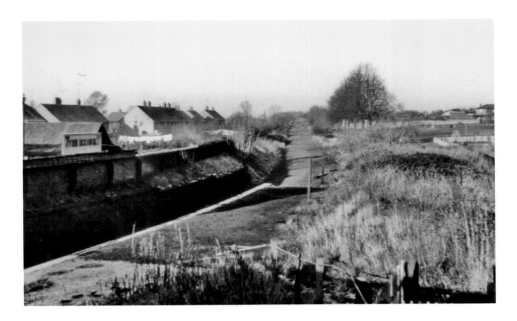

**Ledbury Halt Station,** *c.* **1964**

In 1885, the Ledbury & Gloucester Railway, known as the Daffodil Line, ran from Ledbury to Gloucester, via Dymock and Newent. Much of the line was built over the route of the southern section of Herefordshire & Gloucestershire Canal. The line was built by two companies, Newent Railway and Ross & Ledbury Railway, and operated by the Great Western Railway (GWR). In 1928, the GWR built Ledbury Halt in an attempt to attract more traffic to use the line. On the platform was a tin shelter to keep passengers dry, but tickets had to be bought from agents in town or at Ledbury Junction station. After the line was closed in 1964, the old railway embankment became the Town Trail and the Halt was transformed into Queen's Walk.

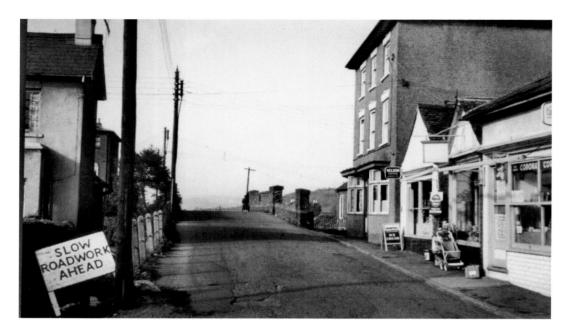

**Bye Street, c. 1950s**

A noticeable difference, other than road widening, is that the three-storey building at the end of the terrace has two storeys. In January 1983, the Golden Crown Chinese restaurant at Nos 79–80 Bye Street was destroyed by an explosion caused by a fractured gas main; two people were killed and the whole building collapsed into its cellar. The building is now occupied by an Indian takeaway restaurant. Another difference is the grocer's which, when the use was changed to a fish and chip shop, was among very few catering establishments in Ledbury.

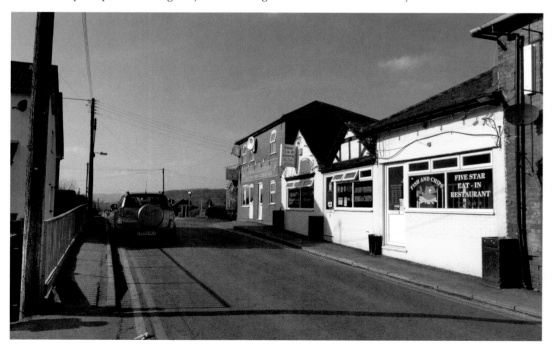

**The Brewery Inn,
Bye Street, *c.* 1880**
A seventeenth-century building, the Brewery Inn, originally the Boat Inn or Boatman's Arms, probably became licensed premises after the closure of a nearby lodging house for the canal workers – that house became the Golden Crown Chinese restaurant. To the east of the Brewery Inn, it is said there used to be a small thatched cottage. The neighbouring cottages were demolished when the ambulance and fire stations were built. The building to the left of the inn is the Youth Centre, scheduled for closure in 2013 and whose future is yet to be decided.

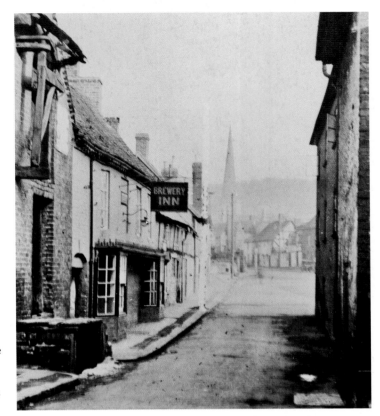

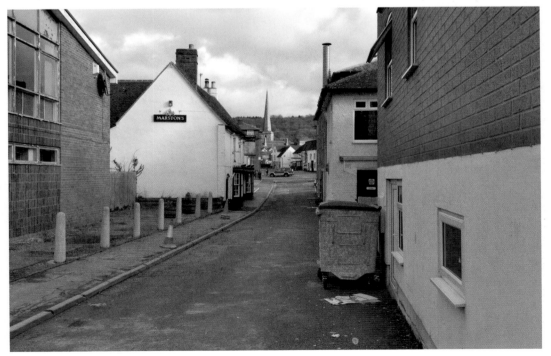

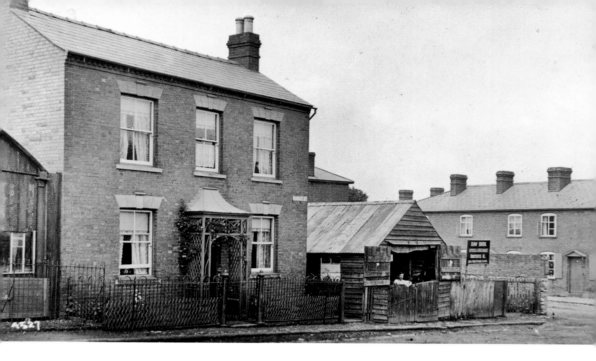

## Newmarket House, Market Street, *c.* 1910

At right-angles to the terrace of houses in Bye Street is Newmarket House, a Grade II early nineteenth-century red-brick house with land occupied by Daw Bros, carpenters and joiners. The building is now occupied by H. J. Pugh, a firm of auctioneers and valuers.

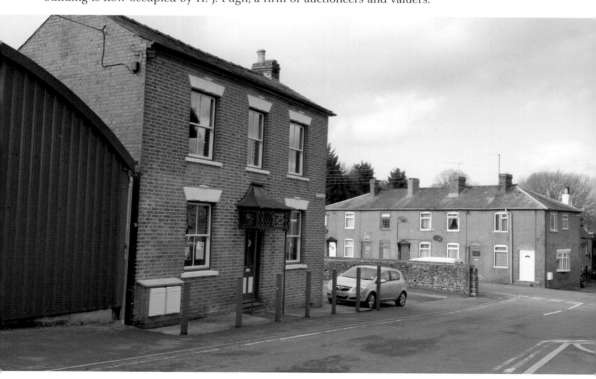

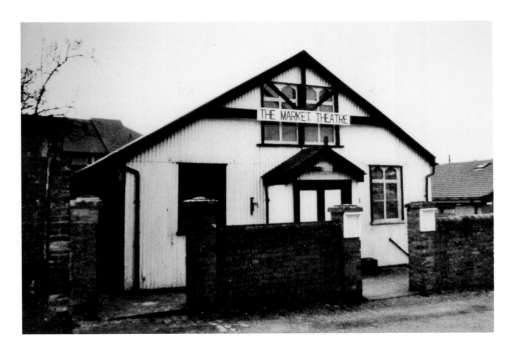

Market Theatre, Market Street, c. 1998

In 1935, some local enthusiasts set up a film-making club. Membership grew and many films were made but lack of space led to the decision to put on a play once a year. In 1938, Ledbury Amateur Cine & Dramatic Society was formed. During the Second World War, Italian prisoners at the camp at Mabel's Furlong set up a theatre in a Nissen hut. After the war, LADS (the 'cine' had by then been dropped) took over the Camp Theatre. In the late 1950s, LADS moved into the old Market Theatre, then known as the Church Room. In 1986, the building was almost destroyed by fire. In 1999, the old building was demolished and Ledbury's new Market Theatre opened in January 2000.

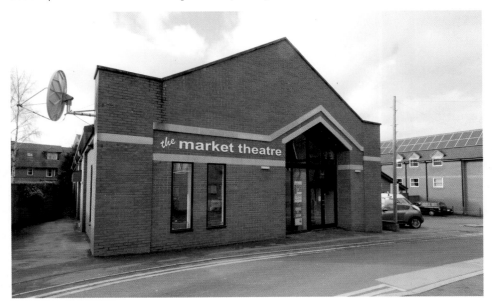

## Cattle Market, Market Street, *c.* 1998

Market Street was opened in 1887 by Ledbury Markets & Fairs Company Ltd. The company was formed for the purpose of removing livestock from the streets. Three acres of orchard were bought for a cattle market with road access from New Street and Bye Street via the privately owned Market Street. The auctioneers to whom the market was leased were finding it increasingly unprofitable to continue. Before the lease expired, half the company had been acquired by a developer. The remaining shareholders opposed the scheme; they bought out the developer and after the lease had expired sold the site for the Ledbury Community Health and Care Centre that opened a new hospital in 2002.

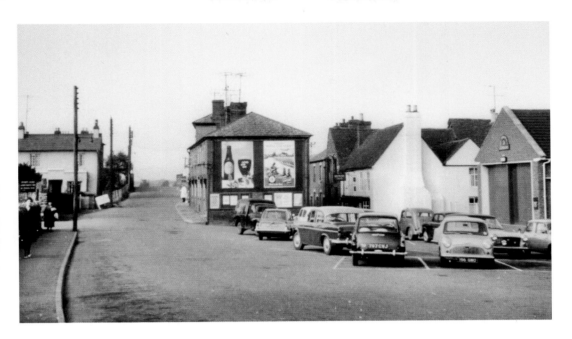

**Bye Street, c. 1963**

On the north side next to the Brewery Inn is the former ambulance station, which closed in 2012. The far end building is now two storey. The terrace of houses is still there, but on the east flank wall windows have replaced an advertising poster site originally owned by Tilley. Car parking spaces are fewer in number. On the south side, the telegraph pole at the entrance to Market Street is there still. The low brick wall of the cattle market has gone, replaced by the high front of the new hospital.

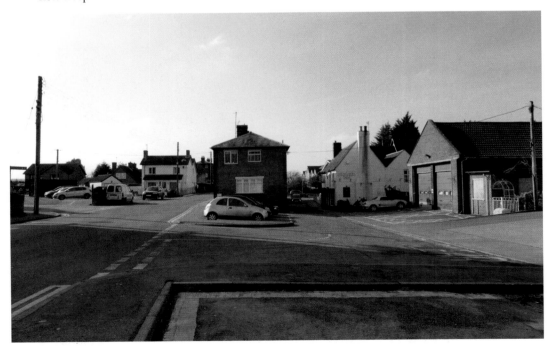

Bye Street, c. 2004

The earliest name for Bye Street, recorded from 1288, was Bishop Street, after the Bishop of Hereford, who probably held land here. Bye Street is considered by some as Ledbury's worst disaster, since most of the original buildings have been demolished. Even so, not all old buildings were worth preserving. On the site of a somewhat tatty warehouse, this development of shops and offices, Sears House, was completed in around 2005.

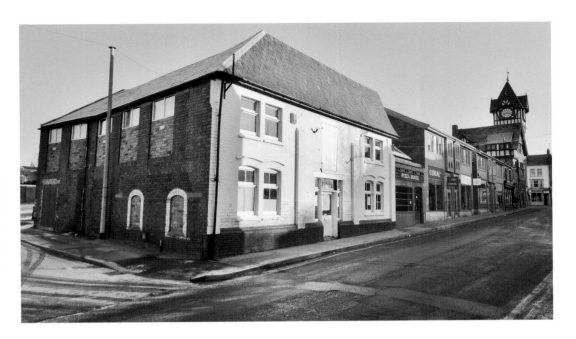

**The Old String Works, Bye Street, *c.* 2010**

The string made was for use in hop yards and this building is all that remains of the old factory and outbuildings that were demolished to make way for the adjoining shops and offices at Sear House. During the demolition, remains of an old tannery were uncovered by the site where the Barrett-Browning Institute now stands. In 1981, the Old String Works was occupied by a carpet shop, and after that a stationery business, until the building itself was restored and converted into offices.

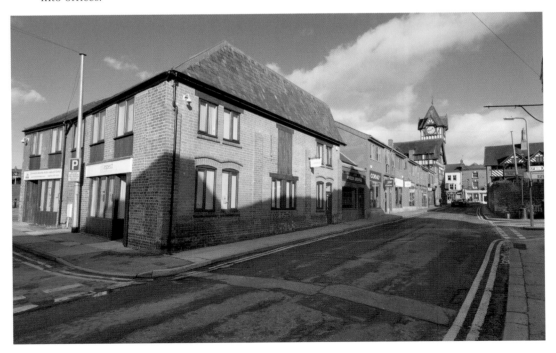

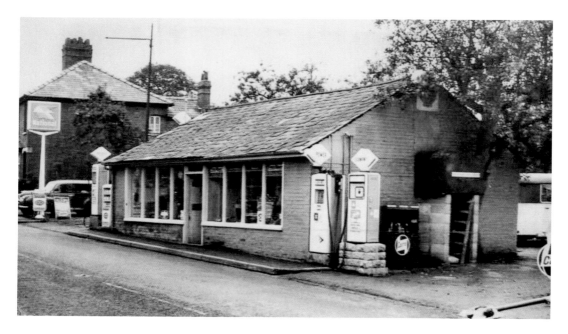

Newberry House, New Street, 1940s

Unlike Bye Street, New Street until the early twentieth century was relatively undeveloped, with numerous orchards, meadows and fields. In the 1840s, the last inn out of Ledbury was the Biddulph Arms (now the Full Pitcher), built to cater for canal workers. In 1860, land at the southern end of New Street was acquired for a cemetery. Gradually, more houses were put up at this end of New Street. Newberry House is probably named after an eponymous fruit and vegetable trading company.

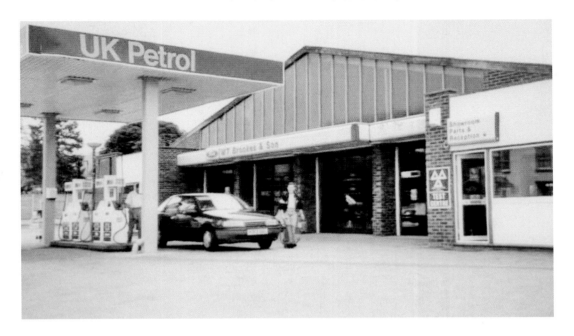

**W. J. Brookes Garage, New Street, 1960s**

In 1850, William Thomas Brookes started out in business with a blacksmith's shop nearby. With the arrival of the motor car, he took up the Ford franchise, selling the revolutionary Model T. In the 1950s a new showroom was built on a site opposite the original premises, and later a petrol filling station. By the 1990s, the family business was in its fourth generation. In about 2004 the business closed and the site was redeveloped for flats.

**The Drill Hall, New Street, 1950s**
Drill halls have been part of British military history since the 1860s when Corps of Rifle Volunteers built premises for drill, funded by benefactors and public subscription. The premises were also available for community use. The local volunteer force was later renamed the Territorial Army centres. The hall was demolished for the adjoining development of a supermarket, previously Gateway, then Somerfield, now Co-op.

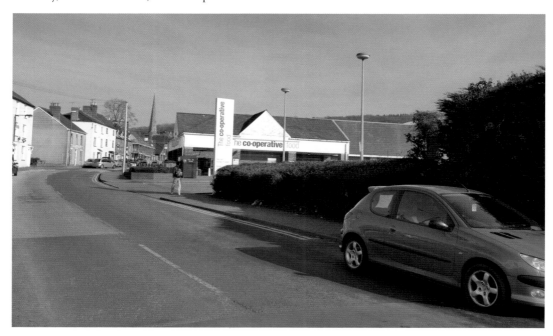

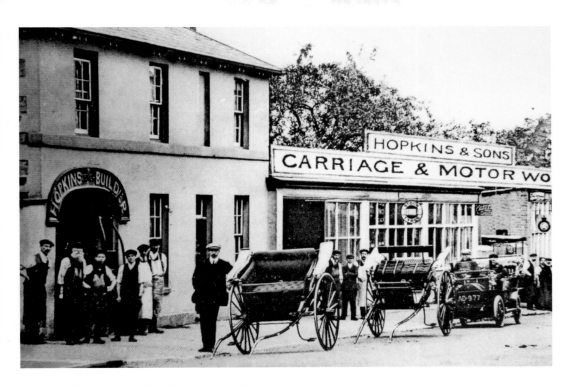

**Hopkins & Sons, New Street, *c.* 1908**

In 1985, George Hopkins & Sons, coach and carriage builders, and Ledbury's oldest company, closed after 150 years trading in the town. Established as carriage makers and repairers at a time when horses and carriages were the only means of travel, the southern wing was demolished in around 1988 for the neighbouring development of a supermarket.

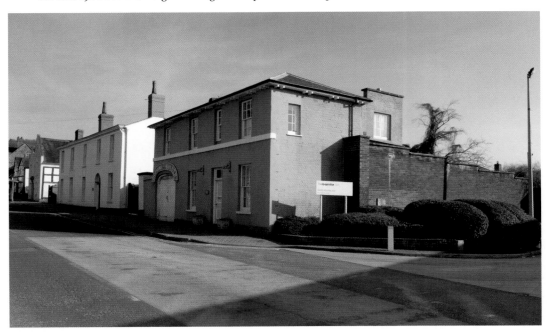

**The Ring of Bells, New Street,** *c.* 2008

Although the late sixteenth-century Talbot Inn on the south side is the better-known public house in New Street, the Grade II listed Ring of Bells was, until around 2009 and despite a short time closed in 2008, the last survivor of three pubs on the north side. In the mid-nineteenth century, the landlord was Thomas Knott, whose hobby was handbell ringing. Behind the bar, it is said he kept a set of ten handbells tuned to the scale of B major. The eighteenth- or nineteenth-century building is now being converted for residential use.

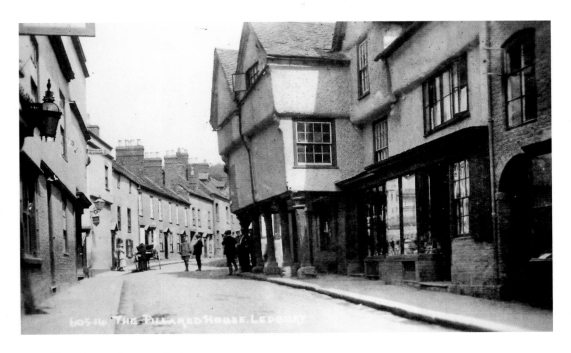

**New Street, Eastern End, *c.* 1905**

New Street is one of the oldest streets in Ledbury and this eastern end was part of the planned medieval town, developed by the bishops of Hereford in the twelfth or thirteenth century. Historically, New Street was populated by professional people, small tradesmen and shopkeepers. During the nineteenth century, as Ledbury expanded, at the western end were the brickworks and canal, in-between the development of residential property.

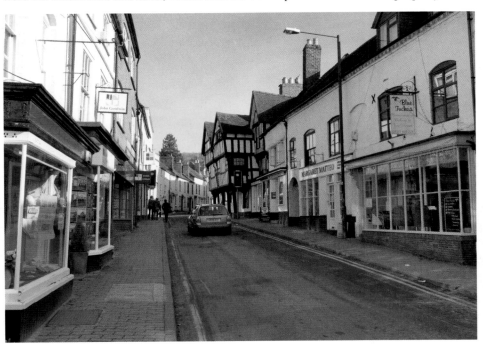

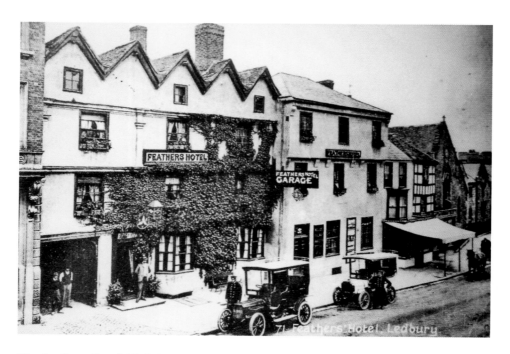

**The Feathers Hotel, High Street, *c.* 1908**

Originally the Plume of Feathers, the Feathers Hotel was the main coaching inn in Ledbury. The south block was built around 1560–70, the north block in the early seventeenth century. Until around 1912, the timber-framed front was hidden by plaster added when the building was remodelled in the eighteenth century. In 1997, during excavations for a swimming pool, deposits related to garden or horticultural activity dating from the twelfth to thirteenth century and associated with a medieval tenement plot of St Katherine's Hospital were uncovered. A feature of the Feathers Hotel is the decoration on the principal posts at first- and second-floor level.

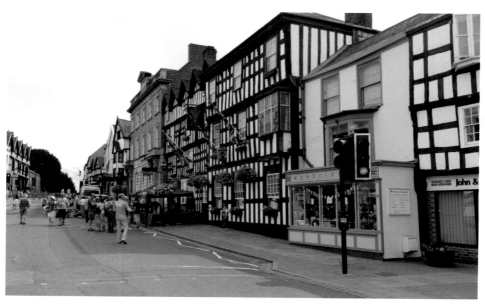

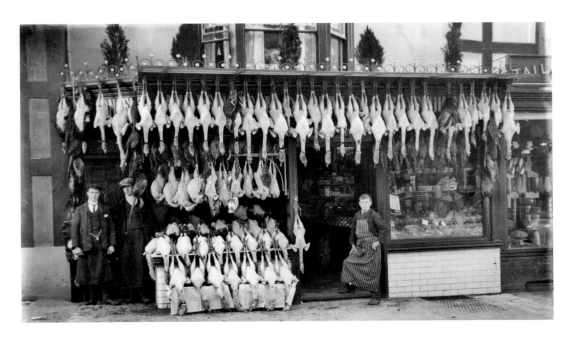

**McDonald & Co., Fishmonger, No. 25 High Street, *c.* 1908**

Next door to the Feathers Hotel was McDonald & Co., a fishmonger's that also sold fruit, poultry, game and ice. Every Tuesday to Saturday, the fish cart left Ledbury at 9 a.m. to serve outlying villages. Around the time of the First World War, the business became known as L. W. Crossley. Later, the premises were acquired by Birmingham Midshires Building Society, and after that society was taken over by the Halifax Building Society; the branch was closed and the freehold of the building sold.

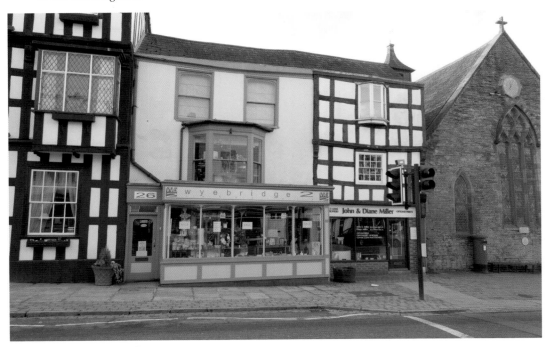

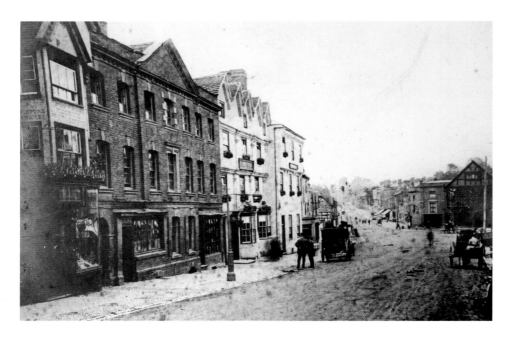

**Webb & Co. Ledbury Old Bank, No. 24 High Street, *c.* 1870**

At the southern end of High Street, Webb & Co. Ledbury Old Bank, subsequently acquired by Lloyds, was to become by about 1941 what the Lloyds Bank building looks like now. Next door is the Feathers Hotel before rendering on the front elevations was removed in around 1912. To the south, at No. 23 High Street, was where Luke Tilley started his business in Ledbury. Towards the background, on the corner of Bye Street, the black-and-white elevation of the old tan yard can be seen; it would be about twenty-five years before the old buildings at the corner of Bye Street would be replaced by the Barrett-Browning Memorial Institute clock tower.

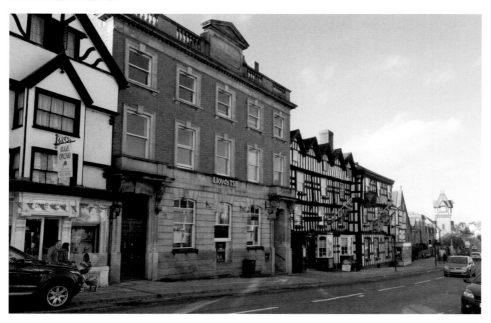

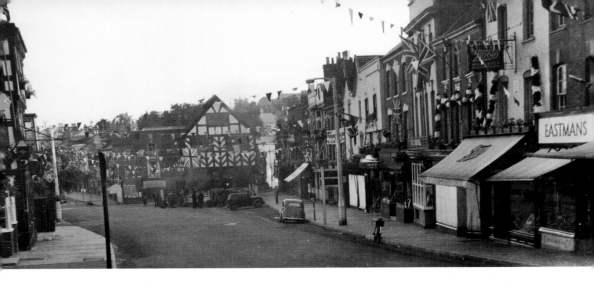

## High Street, East Side, 1950s

For a retailer, where best to open a shop in a high street is not always readily identifiable. One clue is the number and identity of national companies in the vicinity, even though trading positions often vary in importance as time passes. Before Boots relocated to a larger shop at No. 9 High Street in 1993, the best position on this side of High Street was probably closer to Upper Cross. Eastmans was a national chain of butchers, later acquired by J. H. Dewhurst. At Lloyds Bank, opposite, the window boxes would have been a pretty attraction.

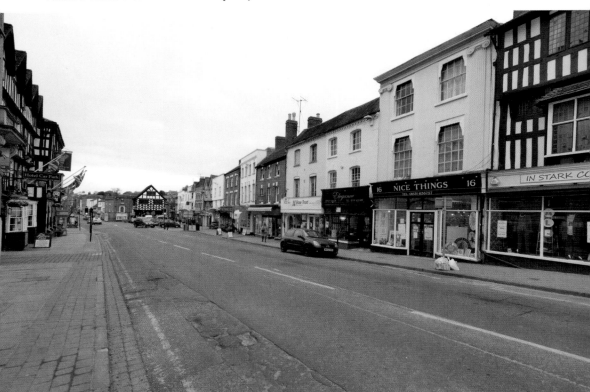

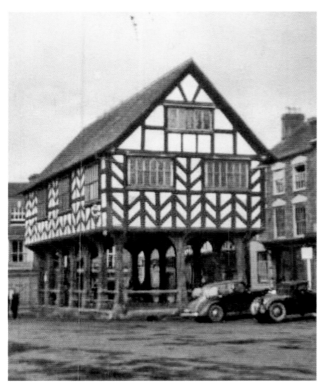

**Market House, High Street, c. 1940**

Shop Row, a small line of structures, was removed in 1617 to make way for a market hall. Originally Lower or Wheat Market, the Market House, as it is now called, was built by John Abel, known as the King's Carpenter, an honour bestowed for his efforts in 1645 when the Scots laid siege to the city of Hereford. Originally there was a shop under the staircase, with ladder access to the first floor, but it was removed in 1818. Market House is Grade I listed. The stilts are oak, but much of what can be seen nowadays dates from the Victorian era when change of use to a town hall and meeting room was proposed. A feature often overlooked at cursory glance is the different patterning on the front and rear elevations.

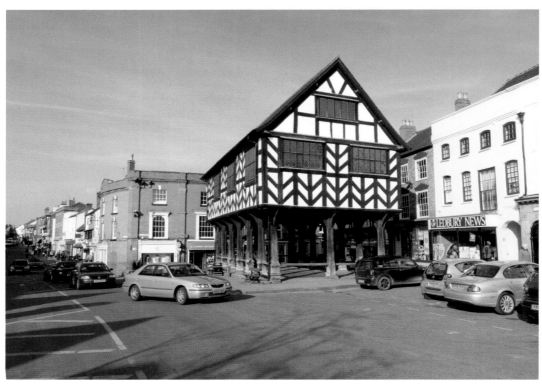

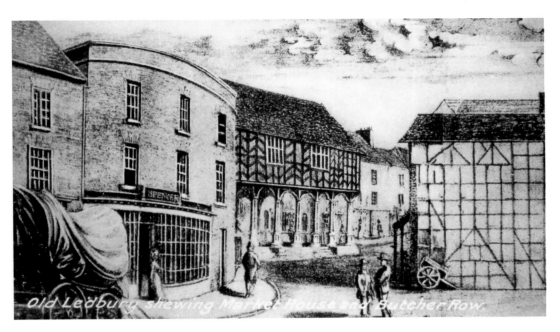

**Butchers Row, High Street, from an Engraving by T. Ballard, *c.* 1820**

Where what used to be Middletown, in High Street, a row of booths stood there for around 700 years that over the centuries became timber-framed structures. Butchers Row was used as slaughterhouses. In 1830, the 'disagreeable practice of slaughtering pigs in the street' was abolished in Ledbury. By 1840, the booths had been removed from High Street and destroyed; all except a couple that in recent times have been restored and relocated. One structure was re-erected in Skipp Alley (off The Homend). When the timber-framing was reassembled, a first-floor beam was put in upside down, as may be seen on the front.

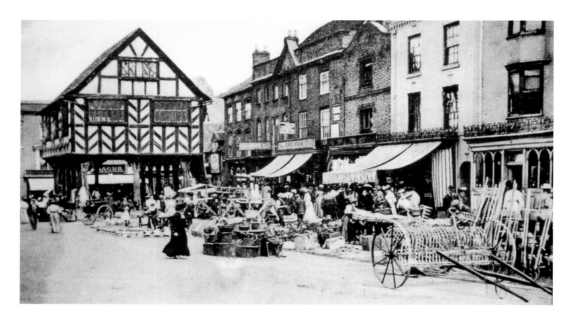

**High Street, Weekly Market, *c.* 1905**
The first recorded Ledbury market charter was issued by King Stephen to Bishop Robert de Bethune in 1138, for a market on Sunday of each week in his manor of Ledbury. Later, the church authorities discouraged trading on Sundays, and Monday became the market day in Ledbury. In 1584 Queen Elizabeth I granted a new charter, allowing a weekly market on Tuesday and two fairs, on the feasts of St Philip and St James (1 May, now 3 May) and St Barnabas (11 June). Nowadays, there is also a weekly market on Saturdays.

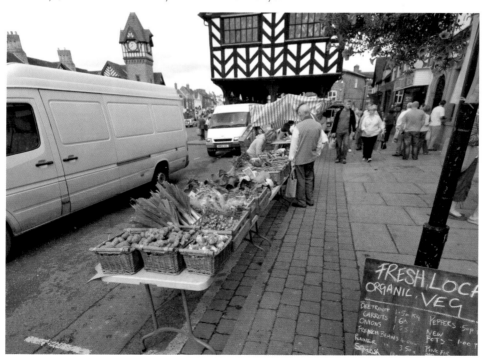

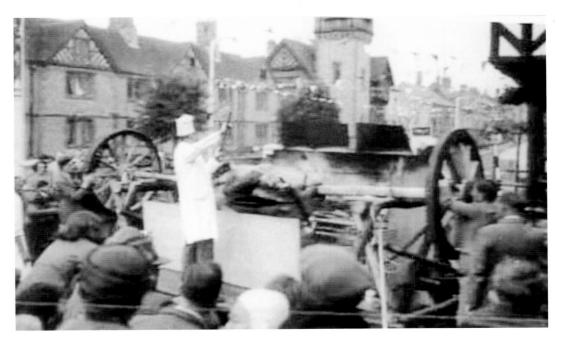

**Ox Roast in High Street, 1953**
Nowadays, meat is barbecued in the High Street at town parties and special events, but in June 1953, to celebrate the Coronation of Queen Elizabeth II, the people of Ledbury went the whole hog and organised an ox roast. Whether the animal was an ox or a cow is unknown; physiologically the difference is not significant but humans differentiate according to use on a farm. To commemorate the 60th anniversary in 2013, Ledbury will be re-enacting the 1953 ox roast.

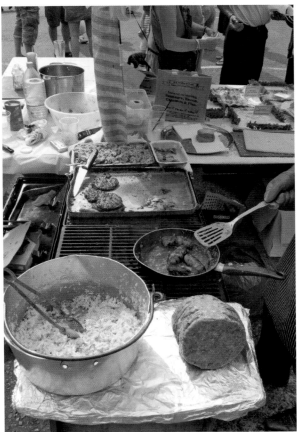

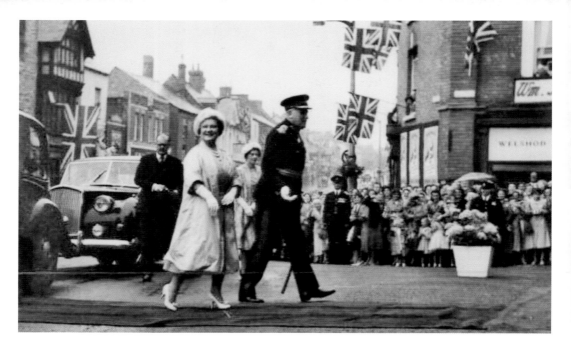

## High Street and Royalty, 1960

In 1934, the Duke and Duchess of York visited Ledbury on their way to Three Counties Show in Malvern. The Queen Mother visited Ledbury again in 1960. In 1957, the schoolchildren of Ledbury and surrounding areas waited near Market House to welcome the arrival of Her Majesty The Queen and His Royal Highness The Prince Philip on their visit to Herefordshire. The Queen was again in Ledbury in 2003, visiting Harling Court. As part of the 2012 celebrations, Ledbury Town Council organised a photography competition on the theme of the Jubilee.

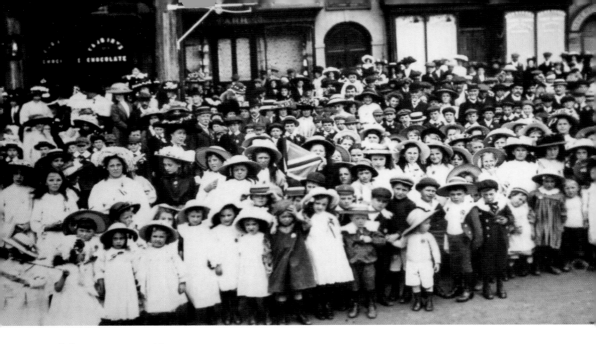

**High Street, East Side, 1911**

This gathering next to the Market House, on the occasion of the Coronation of King George V and Queen Mary, also shows the gate to the Congregational chapel with its signboard over the entrance. Next door, C. Pedlingham, is the original building before the alley was incorporated into what is now HSBC Bank.

**Sealed Knot Civil War, High Street, 1995**

A carnival has been held on August Bank Holiday Monday annually since 1975 when the Ledbury Carnival Association was formed, and before then on and off since the mid-1920s. In 1996, Grace Bradley (*née* Pedlingham), the 1946 Carnival Queen, appeared in the procession. The Sealed Knot took part in the carnival in 1992 and again in 1995, marching through town and staging a battle in Ledbury Park. The carnival is one of the most popular community events on the Ledbury social calendar, attracting around 10,000 people. The butcher's shop is still here; the outbuildings and yard are now the Design Quarter.

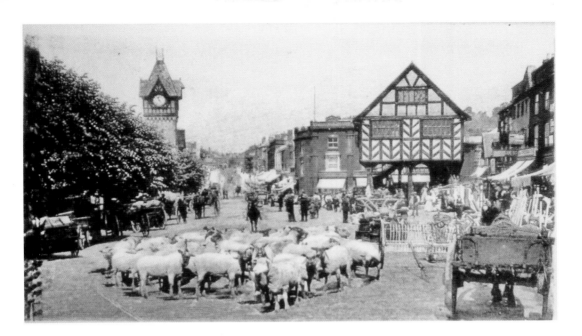

**High Street Proclivity,** *c.* 1905

A bygone era of sheep gathering; now people flock to the High Street closed off to traffic for a town party, such as the Ledbury Poetry Festival seen below. The annual festival, held in July for about ten days, was founded in 1996 by some local residents and first held in the following year. It has since grown to become the biggest and best poetry festival in the UK.

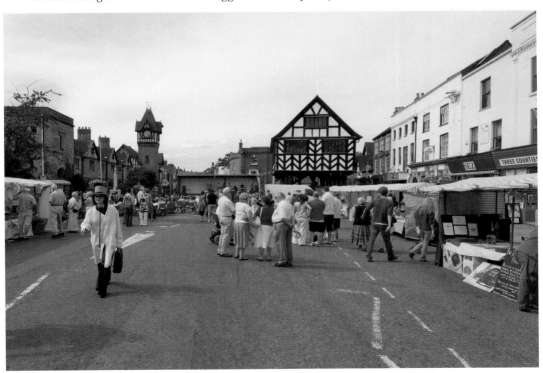

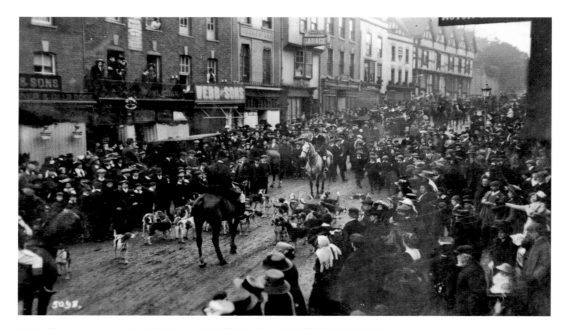

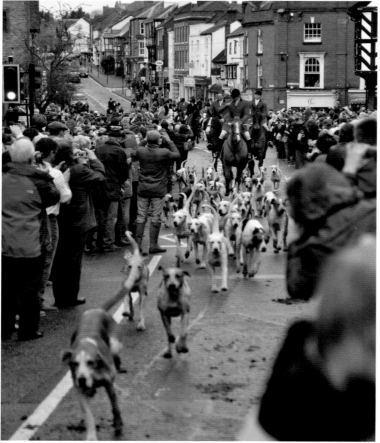

**Ledbury Hunt, Boxing Day, 1910**
The Ledbury Hounds are known to have hunted the area around Ledbury for at least 300 years. The Ledbury Hunt as currently constituted can trace its origins to 1846, when it was decided to set up a hunt on a respectable footing and form a committee. In 1868, kennels were built next to Ledbury Junction station and remained there until 1938. The ban on hunting introduced in 2005 has led to a different form of hunting within the law. On Boxing Day, the hunt traditionally meets outside the Feathers Hotel for a stirrup cup.

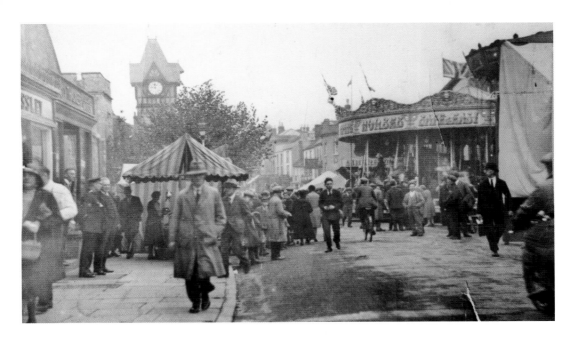

**October Mop Fair, High Street, 1930s**

The October Fair has a long history in Ledbury. Originally a mop fair was for hiring workers. Mop fairs date from when Edward III wanted to regulate the labour market in 1351 at a time of shortage after the Black Death. Farm workers, labourers, servants and craftsmen would work for their employer from October to October. At the end of employment they would attend the mop fair dressed in their best clothes and carrying an item signifying their trade. A tassel worn on the lapel, the emblem of the employee's trade, was known as a 'mop'. The employer would give the employee a small token of money and the employee would remove the emblem and wear bright ribbons to indicate they had been hired.

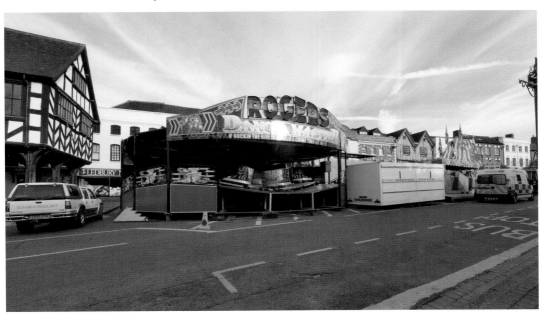

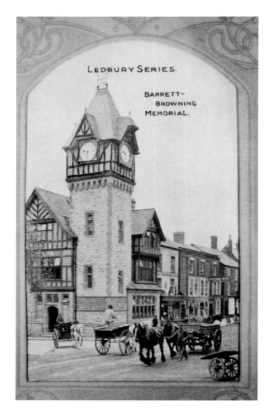

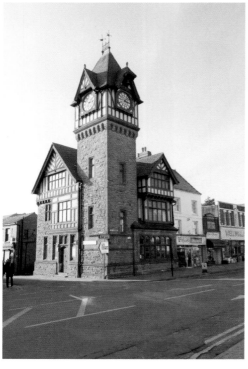

**The Barrett-Browning Institute, c. 1908**
In 1890, the idea was proposed for a clock tower in High Street as a memorial to Elizabeth Barrett-Browning, one of the three famous poets associated with Ledbury. A committee was formed and in 1891 a mock-up tower was erected. Following concern that siting the tower in the middle of the street would cause congestion, an old tan yard, formerly a house belonging to the Hankins family and in medieval times a bakery, was donated for the scheme. By then, the original plan had become ambitious. Designs were invited; forty-five entries were received, and George Hill, a local builder, submitted the lowest tender. The official opening of the Memorial Clock Tower and Institute was in 1896. In 1938, the Institute took on the public library. In 1963, Pevsner described the building as 'really terrible'.

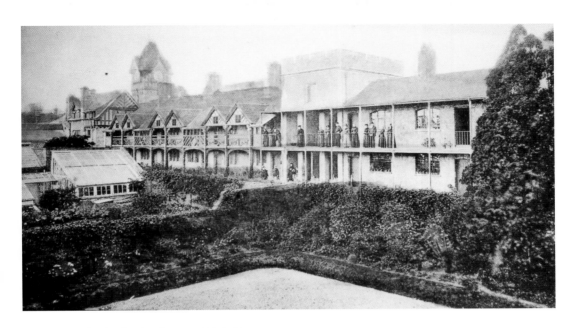

**St Katherine's Almshouses, High Street, *c*. 1905**

The purpose of the St Katherine's Hospital was to remind those who visited the market opposite of the constant need to pray and carry out works of charity. The misuse of the revenue and property of the hospital that features in the history of St Katherine's Hospital was reformed in 1819, the estates sold off after 1945. Originally probably a row of timber-framed buildings, and used as accommodation for the brethren and sisters, the Almshouses were built as two wings, the north side in 1822, the other side in 1866.

**The Master's House, St Katherine's, c. 2010**

The Master's House is one of the oldest buildings in Ledbury, despite its largely Victorian outward appearance. During the Second World War, the ground floor is thought to have been requisitioned and housed the Ministry of Food, while the upper floor became flats. Later, it was a doctor's surgery. At present, it houses Herefordshire Council's Ledbury offices. After restoration, a medieval structure hidden behind centuries of alterations will be open to the public, towards the end of 2014.

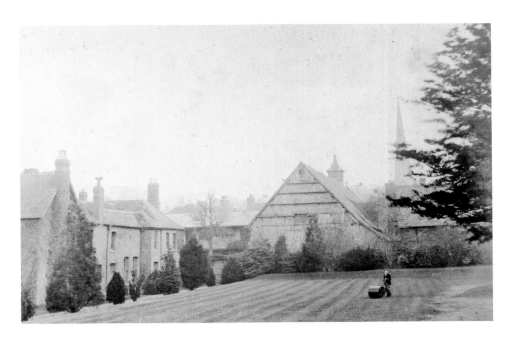

### St Katherine's Car Park, c. 1906

Occupying almost two-thirds of the west side of High Street is the St Katherine's Hospital complex. A rare surviving example of a medieval hospital complex, founded in 1232, rebuilt in the fourteenth century, and named after St Catherine of Alexandra, the buildings and surroundings are more important as a whole than the individual parts. St Katherine's Hall and Chapel were used by inmates of the hospital; the clock on the front, facing High Street, is one of the oldest working clocks in the country. The Master's House and Barn, and what is now the surrounding car park, were the gardens and farm until the mid-twentieth century.

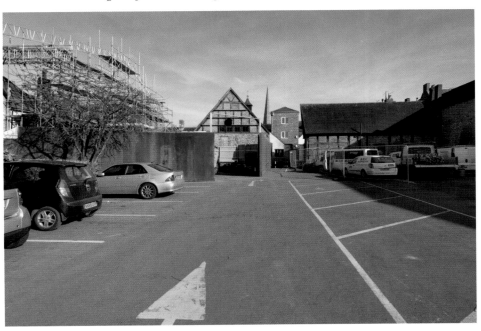

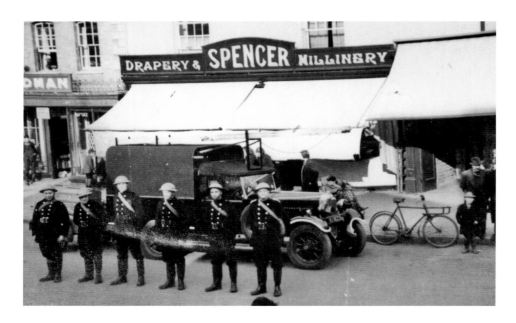

**Fire Brigade Outside No. 9 High Street,** *c.* 1950

From the 1840s until refurbishment and occupation by Boots in 1993, this sixteenth-century building was occupied by drapers. At the turn of the twentieth century, Mr Hopkins, landlord of the Royal Oak Hotel, was in charge of Ledbury Fire Brigade. The brigade was summoned by ringing the bell at St Katherine's. The Great Western Railway drays would be unhitched and taken in a mad dash to Church Street where they were harnessed to the fire engine. The next chief was Mr Gurney, a local surveyor who also owned Ledbury quarry, which supplied the lorry to tow the steamer fire engine, affectionately known as 'Little Nell'. In 1924, George Hopkins & Sons converted a 1912 Austin into a towing vehicle. In 1932 a Bedford was specially constructed as a towing vehicle, which served for twenty-four years.

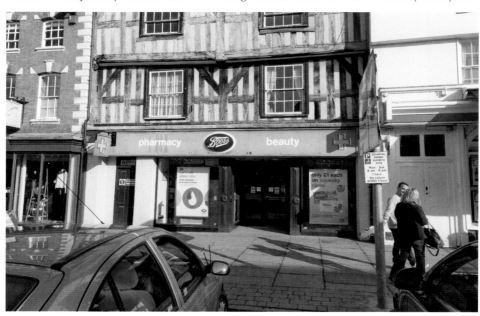

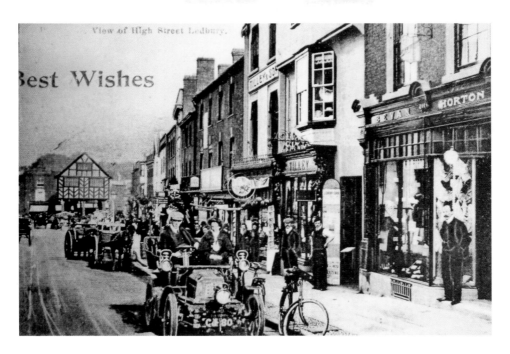

### Tilley & Son, Nos 16–17 High Street, *c.* 1906

Originally a house by the name of Kingshead, subsequently the King's Head public house, No. 16 High Street was bought by Luke Tilley in 1885, who gutted and extensively repaired the building. His son John opened a studio up the alley behind the shop. His other son, William, ran a motor accessories shop from No. 17. The Tilley family business – stationer, newsagent, bookseller and printer, hiring of bicycles and motor vehicles, repair garage, poster sites, and a subscription library – was very successful. John Tilley, a prolific publisher of postcards and photographs, is the man to whom the pictorial history of Ledbury is indebted.

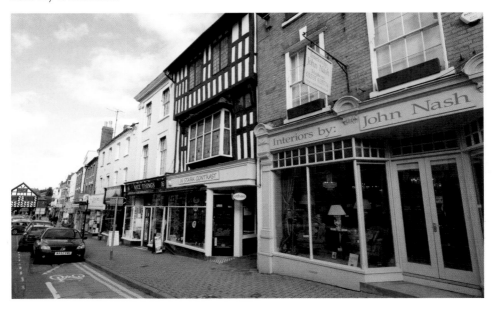

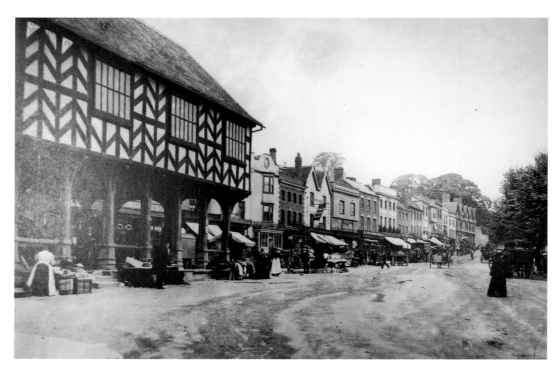

**High Street at Lower Cross, 1890s**
After Butcher's Row was removed from the middle of the wedge-shaped High Street, congestion at Lower Cross eased considerably. In the past, market stalls would have spilled over onto the road, but now are under Market House and just a few metres to the south.

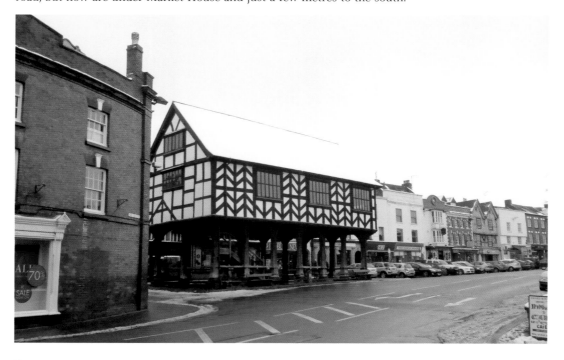

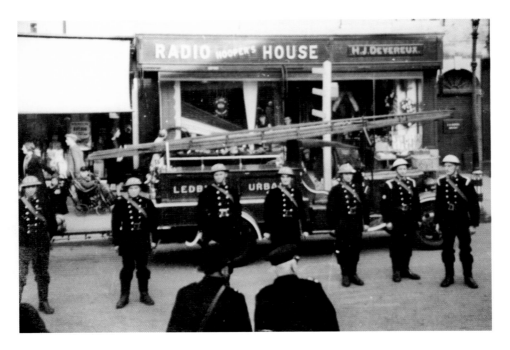

**Hooper's Radio House, No. 11 High Street, *c.* 1950**

Wilfred G. Hooper & Son, established in 1924 (telephone number 113), were the sole Ledbury agents for the television and radio brand names Pye, Bush, Ferfugon and Sobell. The business continued until the 1980s. Of the fire brigade, the specially constructed Bedford in 1932 was for towing a Merryfield Hatfield trailer pump that bore a brass plate inscribed 'Bessie' in honour of the donor. Bessie was retired in the late 1940s. In 2012, Ledbury Town Council donated a horse-drawn manually pumped fire engine, built around 1835, for restoration and display at the Fireworld museum in Northamptonshire.

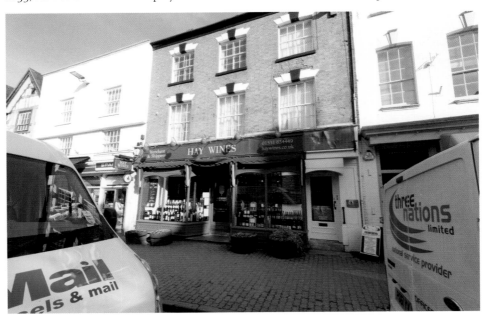

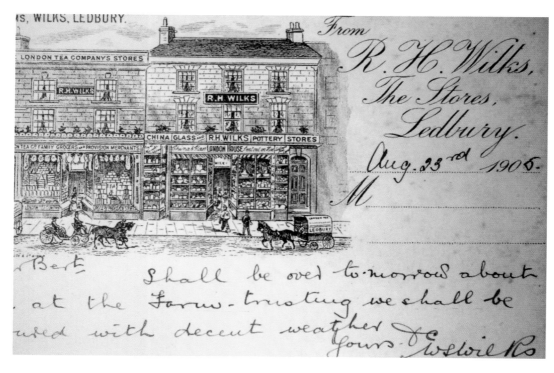

**Wilks, Nos 10–11 High Street, *c.* 1905**

Established in the 1890s as a china, glass and pottery shop, between 1950s and 1970s Wilks Stores (telephone number 25) was noted for choice blended tea and freshly roasted coffee. Roland Wilks used to sell stoneware water bottles that when used in bed had to be wrapped up to avoid injury and scalding. In 2009, two stoneware jars that had been sold by R. H. Wilks fetched £30 at auction.

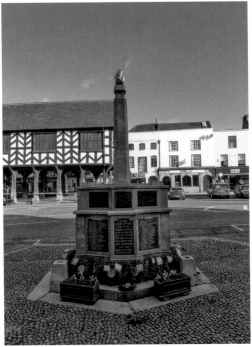

**War Memorial, High Street, 1920s**
Ledbury war memorial commemorates
the dead of two World Wars. In a central
position opposite Market House, the
memorial was constructed in two stages at
the end of each war. It was first unveiled
on Sunday 5 December 1920. The stone is
oolitic limestone with granite plaques for
the names inscribed. On the lower First
World War section are mosaic pictures of
an angel, a soldier and a seaman. On the
Second World War upper addition is a
decorated tile picture of an airman.

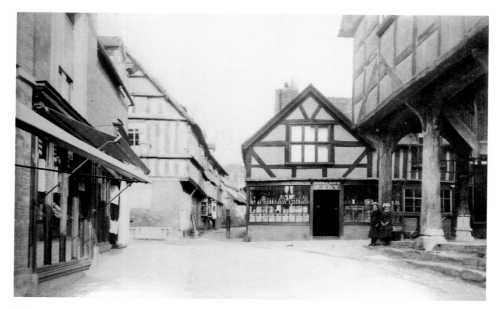

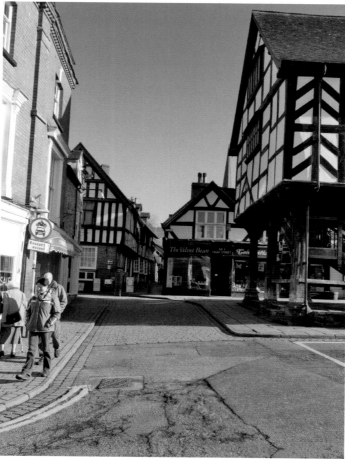

**Market Place, 1890s**
Alongside Market House, between High Street and Church Lane is Market Place, possibly the original open market space before Market House was built in the seventeenth century. The Edy grocery business had enjoyed pride and place from the 1840s until 1902, when the shop was taken over by the India & China Tea Company. Trading positions change and this short stretch of street is to all intents and purposes now simply a continuation of Church Street.

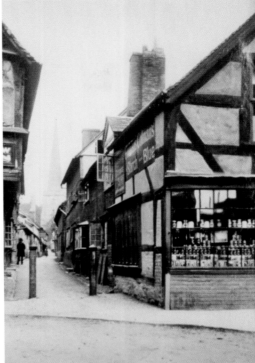

**Church Lane, 1890s**

The cobbled Church Lane, one of the most photographed streets in the UK, is the oldest street in Ledbury, originally the main street from St Peter's church (now St Michael's and All Angels) into town, at the crossroads of the track to Hereford Cathedral. In the Middle Ages, it was apparently called Church End or Church Street, but Church Lane and Church Street by the early nineteenth century. From 1851, it became Church Lane, ending any confusion with Back Lane, properly Church Street. Church Lane follows the line of a stream that ponds behind the church to the River Leadon. The stream is now underground, but originally, as well as the town drains, the water also served the mill for the only bakery in town, on the corner of Bye Street and The Homend.

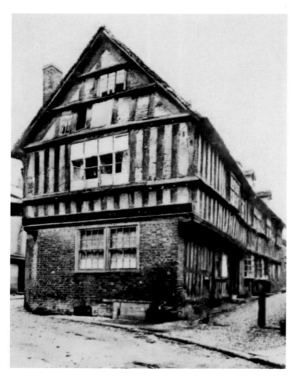

**Town Council Offices,
No. 1 Church Lane, 1890s**
One of Ledbury's oldest timber-framed buildings, currently used as the Town Council offices, the earliest part is at the west end probably built in around 1500, the later east end around 100 years later. Alterations were carried out in the eighteenth or nineteenth century. In 1988, during restoration work upstairs, a sixteenth-century painted room was uncovered. The designs on the walls are floral and based on the Elizabethan Knot Gardens. The original purpose of the building is unclear. The paintings imitate wall hangings and tapestries found in homes of the aristocracy. Although social status was traditionally inborn, perhaps the occupants at the time were, to use the words of a 1913 American comic strip, trying to 'keep up with the Joneses'.

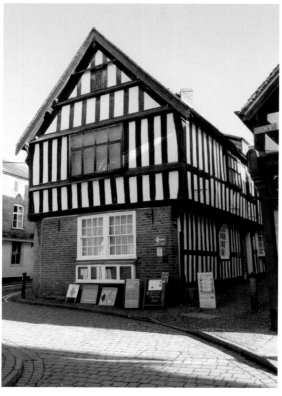

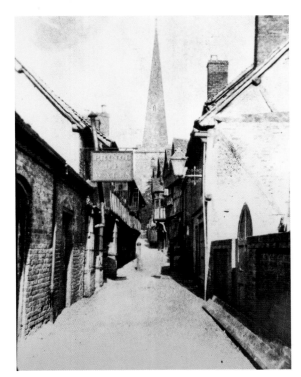

### Church Lane, Prince of Wales Public House, *c.* 1880s

Of the two inns in Church Lane, only the Prince of Wales, a late sixteenth-century building fronting both Church Street and Church Lane, survives. The other inn, the mid-nineteenth-century Jolly Crispin, now a private house, closed in around 1871 after the landlord was refused renewal of a licence following a bell-ringing incident involving 'riotous, violent, and indecent behaviour in a certain churchyard and belfry'. Almost opposite the Prince of Wales is the ecclesiastical gate of the Congregational chapel, now Burgage Hall.

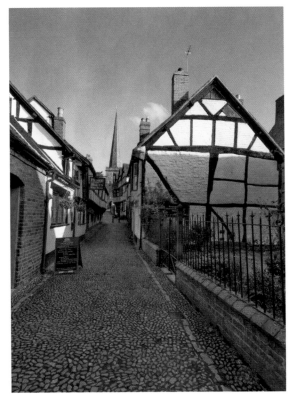

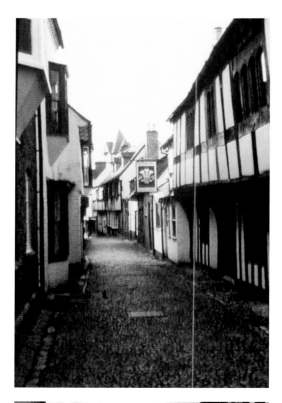

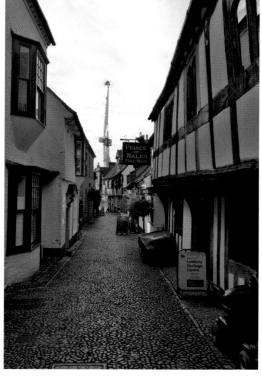

**Old Grammar School,
Church Lane, 1950s**
A fine example of a timber-framed late
fifteenth-century Tudor building, possibly
originally a guildhall; early on it became
a school of chantry foundation (where
prayers were said and masses sung for the
donor) until re-founded in the sixteenth
century and renamed King Edward VI
Grammar School before finally closing in
1862, the school having relocated some
years previously to Oakland House in The
Homend. The building was then converted
into three dwellings, until restored in
1977/78 to near its original form. It is now
the Heritage Centre. The tall structure in
the modern photograph is part of the big
wheel at the October Fair.

## Church House,
## Church Lane, 1880s

Between 1570 and 1620, much of Ledbury was demolished and rebuilt. Church House, built around 1600, was never owned by the Church and only became a vicarage for a few years at the end of the sixteenth century. In 1891, it was bought in a somewhat dilapidated condition and restored by Revd Maddison-Green. The building continues to be one of the oldest private houses in Ledbury. The adjoining property predates Ledbury's major rebuilding period. Known as Abbots Lodge, now a private house and originally two dwellings later amalgamated, for many years it was a vicarage, later rectory, and some timbers have been dated to 1480.

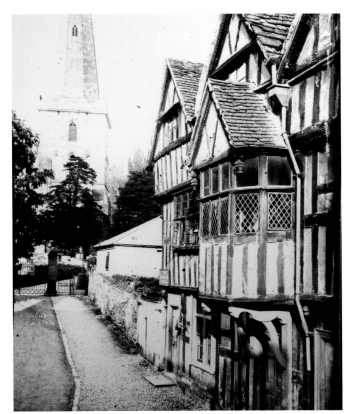

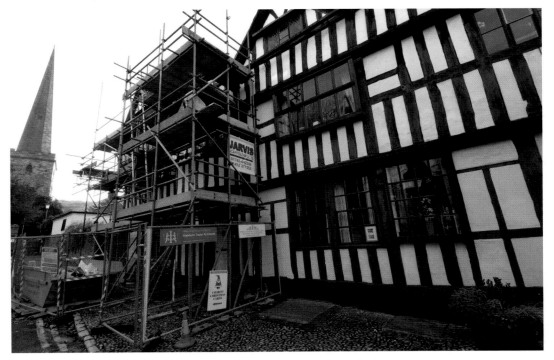

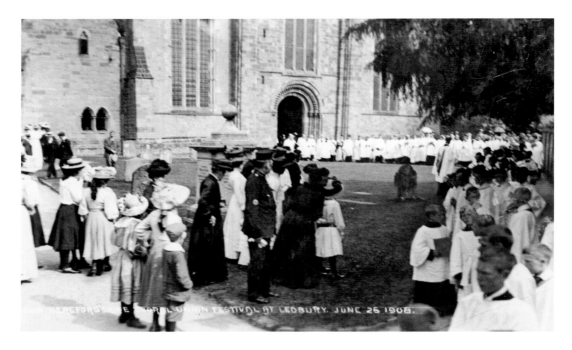

**St Michael and All Angels Church, West Front, 1908**

Under the auspices of the Herefordshire Choral Union, founded in 1862, a festival of parish choirs was held in Ledbury parish church every three years. More than 250 choristers arrived by train, bus, cart and on foot. Rehearsals were held in the morning, followed by lunch in the Feathers Assembly Rooms before the festival started at 2.45 p.m. A collection held in the church for the Choral Union funds raised £5. Ledbury nowadays has two choirs: Ledbury Choral Society, formed in 1962, and the Community Choir, which started in 1998.

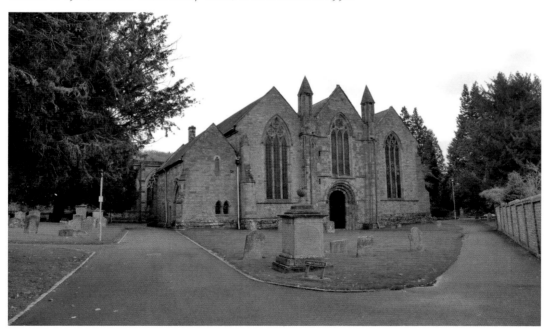

## Church Tower, 1890s

Built between 1230 and 1240, the church tower is detached. There are about forty detached towers in Britain, of which about nine are in Herefordshire. It is not known why the tower was built detached: possibly because the church is built on the course of a stream and the builders were concerned about additional weight, or it is on the site of an earlier church, or maybe it replaced an earlier wooden tower for surrounding hill-camps. The total height of the tower and spire is 202 feet. It is floodlit, and visible from a wide area of the town and beyond.

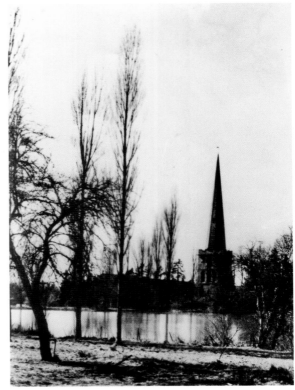

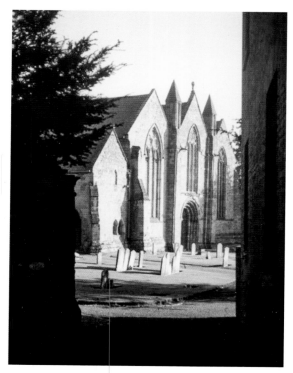

## St Michael and All Angels Church, c. 1965

Formerly St Peter's, the Grade I listed St Michael's and All Angels church is the premier parish church in Herefordshire, second only in size to Hereford Cathedral. Already established as an important church before the Norman Conquest and recorded in the Domesday Book in 1086, the present building, replacing an earlier building, whose foundations may still be seen, was completed in 1140, and extended and modified in the twelfth and fifteenth centuries. The chapter house, built in 1330 with 'ball flower' decorated windows, contains a fine Benedictine effigy, a sixteenth-century parish chest, and relics of the Battle of Ledbury in 1645. The chancel, dating from the twelfth century, has rare 'porthole' windows (which used to run the length of the church), a 'squint' in the north wall, and a recently restored chancel arch. The people of Ledbury and visitors, in unbroken succession, have used this place of community and worship for over a thousand years.

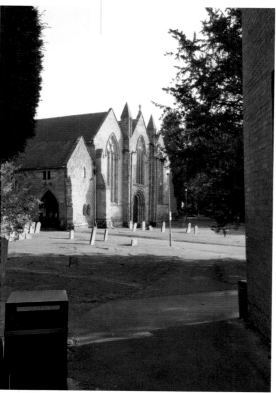